EXPERIMENTS IN WATERCOLOR

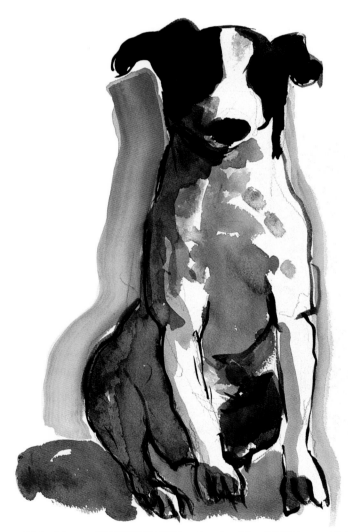

Michael Crespo, QUEENIE STARING, watercolor, 15″ × 10″ (38.1 cm × 25.4 cm)

EXPERIMENTS IN

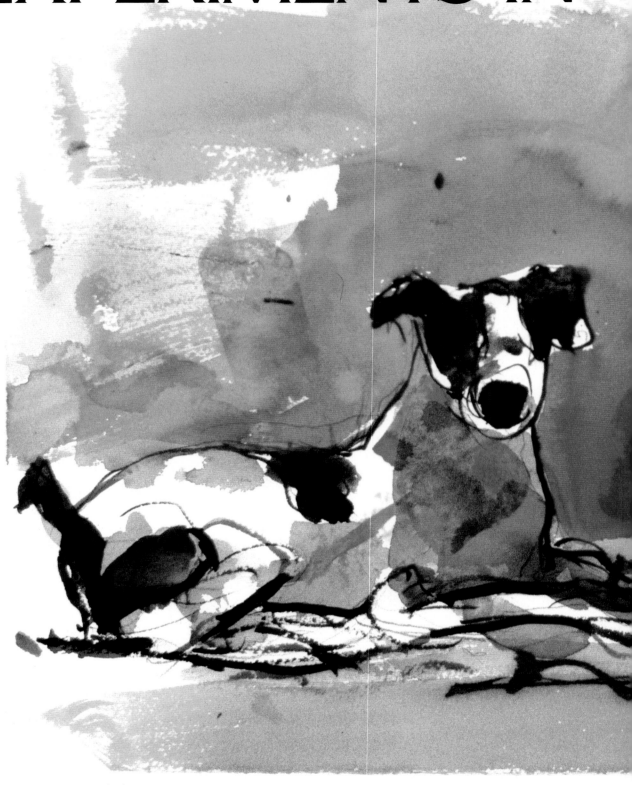

Michael Crespo, QUEENIE AND FLICK, watercolor, 11" × 15" (27.9 cm × 38.1 cm)

WATERCOLOR

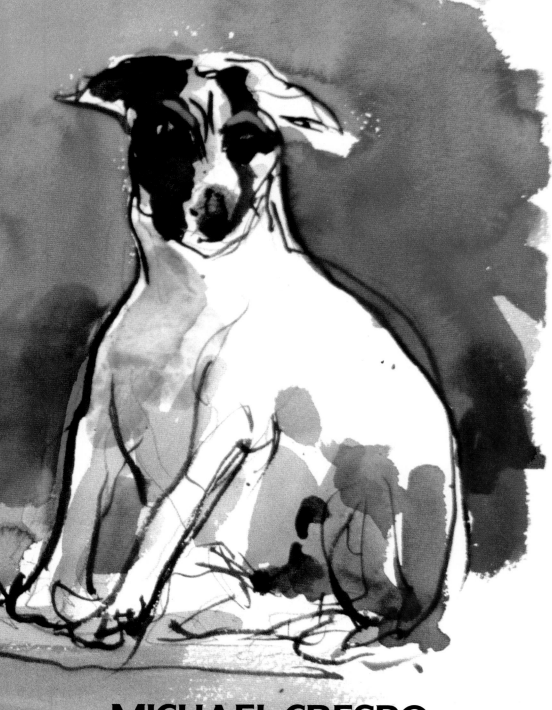

MICHAEL CRESPO

Watson-Guptill Publications/New York

Copyright © 1988 by Michael Crespo

First published 1988 in the United States and Canada by Watson-Guptill
Publications, a division of Billboard Publications, Inc., 1515 Broadway,
New York, N.Y. 10036.

Library of Congress Cataloging-in-Publication Data

Crespo, Michael, 1947–
 Experiments in watercolor.

 1. Watercolor painting—Technique. I. Title.
ND2420.C728 1988 751.42′2 87-28006
ISBN 0-8230-1621-8

Manufactured in Japan

First Printing, 1988

1 2 3 4 5 6 7 8 9 / 93 92 91 90 89 88

Edited by Brigid A. Mast
Graphic production by Ellen Greene

For Joel West (1964–1987)

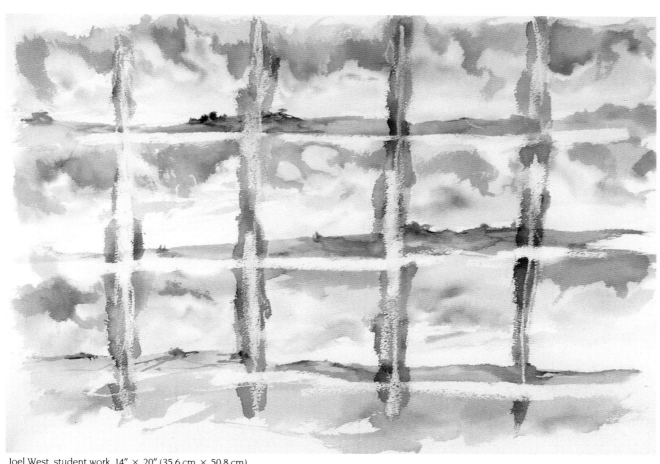

Joel West, student work, 14″ × 20″ (35.6 cm × 50.8 cm)

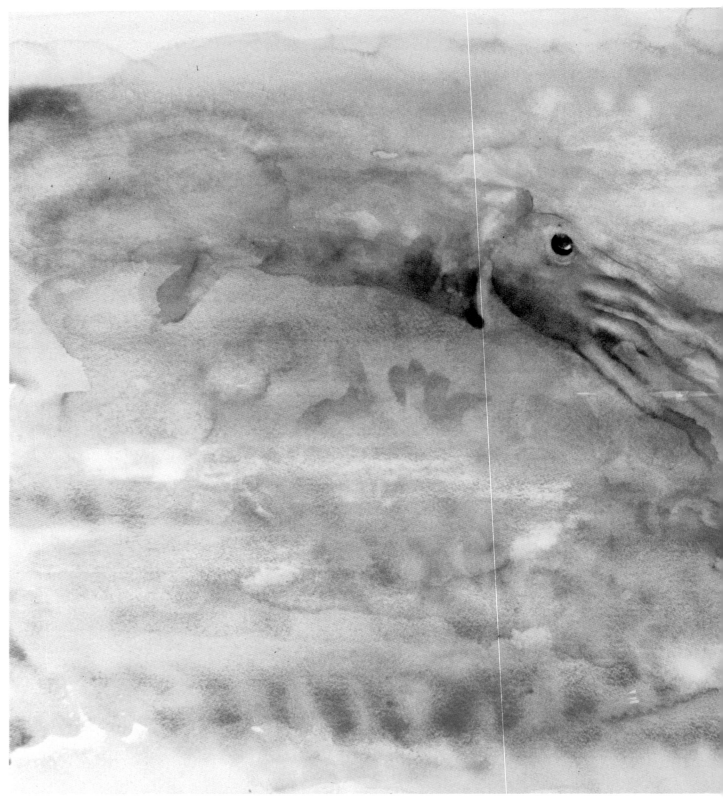

Michael Crespo, MURMUR, watercolor, 22″ × 30″ (55.8 cm × 76.2 cm)

Contents

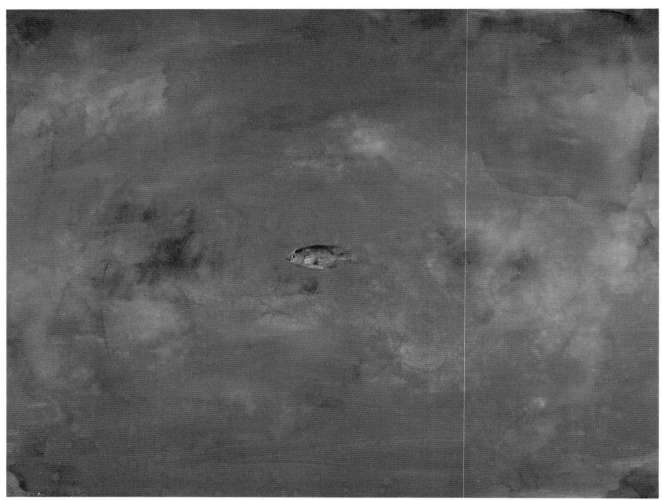

Michael Crespo, LOSS OF GRACE, watercolor, 22″ × 30″ (55.9 cm × 76.2 cm)

Introduction

This past spring, I spent a morning viewing an exhibition of my own work. I certainly cannot deny that I was there to gloat a little over my recent paintings, but, more important, I had gone to see and evaluate them as they appeared on public display. Of course, I had continuously appraised them in my studio as I worked, but not with the same objectivity that I could attain posing as just another spectator in this formal context. As I roamed about the twenty watercolors hanging in the gallery, I recognized my strengths and my failures. I saw my technique flourish; I saw it wane. I relived the excitement of painting some of them and the struggles I had with others. But despite those predictable highs and lows, my spirits climbed as I realized, looking at my work, that I was still a student. I was not making paintings about things that I already knew. I was asking questions. I was seeking, and occasionally finding, the answers that lay still in the surface of paintings.

This continuing search is what my books are about. I ushered it in in the first, *Watercolor Day by Day*, and it continues in this volume, which is derived from the second course in watercolor that I teach at Louisiana State University. I have provided twenty more daily lessons and assignments to encourage and enlighten you on your search for the balance of elements that best explains your most personal relationship with nature—nature meaning *all* that surrounds you, both seen and unseen. These lessons are about the ebb and flow of technique and idea as interchanging motivations to paint. They are illustrated with my own responses and those of other artists I respect. But the most significant paintings here are those of the students, who stir up such excitement with their intelligent, uninhibited explorations.

Painting is a cumulative experience, and although you may not be as comfortable with some of my assignments as you are with others, work through them all in the sequence I have designed. You must try to experience as much as you can so that you can make the most informed choices regarding what you carry with you to the next painting. As you paint, remember to maintain the spontaneous, expanding role of student, keeping your eyes, mind, and heart always open to what you're making.

Do well and enjoy yourself.

Materials

I can think of no more tantalizing experience than sauntering through the aisles of a well-stocked art supply store, feasting my eyes on shelves of endless possibilities. I never leave without at least one bonbon—a sleekly packaged block of Italian paper, perhaps, or a plastic water jar that expands accordion-style. It may be foolish to think that a new brush will unleash previously undisclosed talents, but it's just as foolish to assume that it won't. It may well be that a brush of slightly different balance and cut, or a paper with a tad more surface texture, just might produce a new and fruitful mark. At the very least, something new might provide the stimulus to jolt me out of the occasional lapse in creativity. There are also those purchases that proved completely useless as painting implements but were so aesthetically pleasing as objects that they claim prominent positions on my work table, impressing all visitors to my studio. Collecting art supplies is a fierce avocation of most artists, and with the enormous competition in the marketplace, it doesn't have to be expensive.

I'll spend some time now reviewing the necessities and reporting on some worthwhile materials that I've researched since my recommendations in *Watercolor Day by Day*.

Brushes. I still recommend a no. 12 round sable or synthetic sable. I use the Kolinsky sable made for and sold by Utrecht Manufacturing Corporation. The Series 7 Winsor & Newton remains the premier round sable watercolor brush, abundant with luxuriously absorbent bristles, but it is very expensive. I suggest my students purchase either Winsor & Newton's Series 239 or the Japanese-made Loew Cornell 7000. Both contain synthetic bristles, are highly versatile and durable, and are quite inexpensive.

You'll need a small brush to do linear work. I use a variety of brushes for this purpose: a no. 3 script, a no. 2 round, an assortment of different-sized bamboo brushes, and my favorite, a small sumi brush, with an exquisite lacquered handle, that both looks good and works well.

There are a number of brushes that are used for applying washes and are also good mark-makers. A one-inch flat works well but is a little small for laying down a wash on a large format. To accompany it, I recommend a one-inch, short-handled brush with inch-and-a-half long bristles. It is made exactly like the small house-painting brushes found in hardware stores except this brush has very fine white synthetic sable bristles. A number of companies make them; mine is a Holbein Series 246. This brush holds a lot of wash and makes many beautiful marks, and the long, taut bristles are excellent for splattering paint across a page with a mere flick of the wrist.

Another constant companion of mine, good for washes and a variety of marks, is a two-inch Japanese hake. It's large and flat and very lightweight, and I've found myself at the end of many paintings having used no other brush than my hake.

You'll never own too many brushes. Although you may consistently use only two or three, your preferences may shift over the years as your ideas and visions evolve. And besides, there's great security and beauty in a coffee can stuffed with your unique assortment, probably acquired during weaker moments in the art supply store.

Paint. Use only tubes of watercolor paint, squirting half out onto a compartmentalized plastic palette and saving the remainder for mixing washes and large amounts of a particular color. The paint on the palette will dry, but it can easily be replenished by spraying with water before each painting session.

Fortunately, there are a number of superior-quality paints for you to choose from. I have worked extensively with all the brands I am about to mention and can recommend all of them without hesitation. No one doubts the high standards Winsor & Newton maintains in their very popular watercolor series. The colors are dense and vibrant, as are the Grumbacher Finest watercolors, which dominate my palette. Slightly less expensive, but still of extraordinary quality, are the Italian Maimeri colors. Most of my students are interested in the least expensive offerings of the major manufacturers. I recommend the Grumbacher Academy series. The quality is high and the offering is varied.

I start off all of my beginning students with a limited palette of ten colors: alizarin crimson, cadmium red medium, cadmium orange, cadmium yellow medium, phthalo green, phthalo blue, ultramarine blue, burnt sienna, sepia, and ivory black. Limitation is often an inducement to more creative mixing and transparent overlaying. It's also easier to work out basic color theory if the selection is not overwhelming. However, I do suggest that in time the palette should expand to reflect your individual requirements and tastes. Its makeup will gradually change over the years as you experiment with different brands and hues and as your vision and expression mature. Here is my present palette, which I find more than adequate: Grumbacher red, Venetian red, brown madder, alizarin crimson, cadmium orange, lemon yellow, cadmium yellow medium, chrome yellow deep, Indian yellow, new gamboge, indigo, phthalo blue, manganese blue, cerulean blue, ultramarine blue, cobalt blue, phthalo purple, phthalo green, oxide of chromium, burnt sienna, raw sienna, lampblack, and Chinese white.

This brush has been doing a lot of work for me lately. It's my one-inch utility brush. It's made exactly like a small house-painting trimmer but has synthetic sable bristles. It's very inexpensive and I highly recommend it.

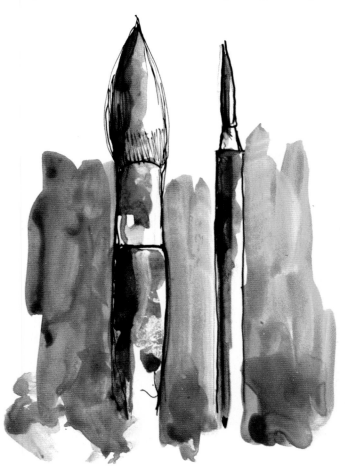

No matter how many brushes I experiment with, these two seem to touch down on just about every painting. On the left is my no. 12 round Kolinsky sable, and on the right is a small, slender sumi brush that is probably the most perfectly balanced brush I've ever held in my hand.

Here's my two-inch Japanese hake. Although I occasionally use it for washes, it is well-suited to more detailed work. The long, narrow row of bristles is remarkably versatile and flattens out wonderfully for drybrush techniques.

Materials

I painted the colors of my palette over waterproof black ink to determine their relative opacity. I suggest you do the same with your colors. The chalky opaque colors are visible over the ink. Those colors that completely fade into the black are usually the staining colors. The transparent nonstaining colors are still recognizable as they sit on top of the ink. Some of these may even be a little more opaque than others. Although this method of testing is not exact, it will give you a good working knowledge of how your colors might perform in a painting.

Watercolors are usually classified as either transparencies, stains, or opaques. Nonstaining transparencies make the best glazes, because they literally lie on top of the base colors, while the stains penetrate and actually stain the colors below. Opaques cover in varying degrees of opacity. Before you begin any of the problems in this book, test and identify the characteristics of your colors for future reference: Paint a vertical band of black ink, let it dry, then paint a swatch of each color over the band. When they're dry, it's easy to see whether each color is covering, staining, or lying on top of the ink.

Paper. I strongly advise that you paint on as many papers as possible so that one day you will find a particular product that suits you perfectly. Until this past year, I used only two papers, 300 lb. Arches cold-pressed and 300 lb. Fabriano hot-pressed. Although the cold-pressed paper worked well for the majority of my ideas, the contrasting slick surface of the Fabriano was called for occasionally. But one day, enticed by an advertisement, I ordered a supply of Saunders Waterford Series 140 lb. cold-pressed, and nothing has been the same since. The paper is extremely durable; it doesn't surrender a shred of its delicately textured surface to my constant scrubbing and lifting out. My technique is nothing short of paper abuse, and in the past I'd occasionally lose a painting to paper breakdown, but now I can flail away uninhibitedly, assured that my surface will not fall apart. Incidentally, before painting I staple the dry paper to a Homosote board with a light staple gun. This prevents buckling as I wet the paper.

The majority of my students prefer the compact and easily transportable blocks, which are tablets of paper glued together at the edges. Although blocks are essentially prestretched and have a solid backing, which is convenient for landscape painting, they are usually more expensive than paper bought by the sheet, and the choice of weight and surface is limited. I remain a champion of the standard 22″ × 30″ loose sheet. Whichever you choose, make certain that it is made of 100 percent rag and is at least 140 lb. or heavier. I'm not so adamant about the surface you choose. My choice is cold-pressed, which is somewhat coarse but not as coarse as "rough." Hot-pressed paper has a smooth, less absorbent surface. These textures may vary with different manufacturers.

Many artists like to explore the peculiarities of the handmade papers available now through many art

suppliers. If you are interested, you might even seek out a craftsperson in your area who is molding his or her own variety for limited sales. These papers are the fruit of much work, and I must warn you that they are usually very expensive. I will point out some examples of works on handmade paper further along in this book.

When you consider that a single sheet of paper can be cut into a number of different formats, and that you get two chances to paint on each, front and back, it's a bargain. So indulge yourself and experience as many varieties of paper as you can. Someday, as happened to me, one may find its way into your studio that will become a friend for life.

Miscellaneous. This category includes all the rest of the stuff that makes painting possible; your needs will vary with your working habits and techniques. My work table always seems to be spilling its contents onto the floor, so I must have a full complement of accessories. I never seem to be in need of anything except ideas and talent. So I've surveyed my studio and made a list that should help you supply your work space.

Palettes come in many shapes and sizes. I use one large, store-bought, hard plastic palette with wells for paint around its entire perimeter. I use one enameled butcher tray, made in China and now sold for artists' use. I use one old, cracked, white Buffalo china platter that was handed down through the family; I just can't bring myself to throw it away and besides, it makes a great palette. Also on hand are a stack of the plastic plates that accompany frozen microwave dinners, in case I fill up the other three surfaces. And last is a tiny compartmentalized palette that I use only for mixing colors with Chinese white. I refuse to have the chalky, opaque color contaminate the transparencies.

Mixing cups for mixing washes or considerable quantities of particular colors. I counted 32 of them strewn about, for if I fail to use all of the color, I let it dry and reactivate it another day.

Coffee cans and jars for holding my brush collection upright. Never leave your brushes lying around on the table. The bristles tend to get mashed into unwanted shapes, and they're not always readily available when you need them.

Jars and large freezer containers for painting and brush-cleaning water. I've found a water container to fit every vacant spot on my table. I never have enough clean water, and the nearest faucet is downstairs. Keep as much as you can in your immediate vicinity. Your brushes and colors will stay cleaner. Save the lids for the smaller containers; they'll be good for carrying water outdoors for landscape painting.

Bottle of fresh water for mixing washes and topping off the other containers. It will also function as your well in the landscape.

Roll of paper towels and a box of tissues are essential for lifting out paint, stippling in paint, cleaning up paint, and many other uses.

An all-purpose mister with an adjustable nozzle is as dear to me as my brush. I use it to activate the dry paint on my palette, to wet down paper for wet-in-wet technique, to saturate areas for lifting out, to make textures by spritzing surfaces of dry paint, and to mist the rosemary plant that sits in the window to my left.

Two synthetic sponges, the small size sold in supermarkets, for regulating the amount of liquid in my brush, printing texture on my paintings, and cleaning up spills.

A straightedge for measuring and ruling formats, cutting up sheets of paper, and drawing straight lines.

A mat knife, X-Acto knife, and razor-sharp Italian stiletto, all of which I use to cut paper, score texture into paper, and cut away shapes in the top layers of paintings to make highlights.

Pushpins, staple gun, and paper tape, all used to either stretch paper onto my Homosote working board or attach works in progress on the wall in front of me for perusal.

Drafting tape for masking out boundaries on the edges of the paper.

My journal and assorted pencils and pens are always nearby for jotting down colors for future reference, thumbnail sketches, notes on future paintings, notes on future books, phone numbers, art supply lists, grocery lists, and whatever else important has to be recorded on any given day.

There are two more objects on my table: my beautiful dark gray marble sumi ink well and the accompanying ink stick, cherished gifts from a good friend that are used to paint with occasionally but more often are just fondled.

DAY 1
Beginning Again

Even if you're extremely dedicated, faithfully painting on a regular schedule, there will be periods of time when the water evaporates from your brush-cleaning bucket and the colors dry up on your palette. For my students, the culprit may be one or all of the semester breaks; my own routine may be interrupted by a vacation, a period of intense work in another medium, or a simple lack of inspiration.

Eventually, however, new ideas and the urge to paint will propel you back to the studio. And then you must face the often daunting prospect of beginning a painting. Fear of failure and all its subsequent tensions inhibit me whenever I approach the vast, empty white sheet of paper that awaits me. But I have learned to overcome this initial apprehension, and you must, too.

Let's take a little time now to analyze what we do when we paint and allow ourselves to drift effortlessly back into the full painting process.

Normally, you would begin with an idea about something you're looking at, or a vision in the mind's eye, or just a phrase begging to be illustrated. Today, the only subject matter will be the colors and marks that illuminate the movement of your hand.

Exercise: Letting Go. Your first task is to clear your mind so you can appreciate the sensations of painting. To facilitate this, I suggest you choose some piece of music to play in the background, something that relaxes, comforts, even inspires you. Music, in its inherent abstraction, is remarkably symbiotic to painting and is the quickest way to lift the mind from its pedestrian preoccupations and let it soar uncluttered and creative.

Place before you a full sheet of clean white paper and a full palette of moist colors. Choose a brush you like and mix a large puddle of your favorite color. Slowly carry the fully loaded brush to your paper.

While your mind loses itself in the music and your eyes focus on the spot where your brush tip releases its colored cargo, allow the hand and brush to move where they will, marking the paper as if responding to a force deep within you. Feel the brush in your hand. Feel the pressure your fingers exert on it. Release any tension you feel in your hand and arm. Relax your grip until the brush almost falls from your fingers. Feel the wet bristles as they trace the surface of the paper. You may even find your brush marking time to the music. Keep the brush loaded, and allow any and every motion and mark to occur.

Celebrate. This is the pure, unobstructed core of any painting process. Continue until this color has wandered from corner to corner of the page.

As the first layer dries, contemplate a new color; perhaps the first color will guide you. You may even wish to change your music, seeking a different structure, a different mood. When you've mixed the second color, proceed as you did with the first. Find your pace. Meditate on the mingling and interacting colors. Continue to let your impulses and intuitions guide you.

Does it bother you that you have no subject matter? Remember that you are making a painting about painting. Color, value, light, rhythm, pattern, emotion are all present. There will be time enough later to think about subject matter.

Build at least four layers of color before you stop, and then do not be too quick to discard this "action" painting. Tack it to a wall somewhere in your work space and observe the freedom, flow, and spontaneity. In the days to come, this lyrical, ephemeral meandering of color may serve as a reminder of the expressive tranquillity and heightened sensitivities that are so essential to successful painting. Remember: relax, love what you're doing, and don't take yourself too seriously. Let your critics do that.

Michael Crespo, MEDITATIONS ON DR. JOHN AND BACH, watercolor, 22" × 29" (55.9 cm × 73.8 cm)

I seldom work in my studio without music in the background. It's a friendly studio companion. This exercise, which I practice frequently, clears out the cobwebs and brings me back to a more heightened awareness of the elements of painting, as well as the soothing intelligence of music. I was listening to the jazz piano of Dr. John and some J. S. Bach preludes performed by Glenn Gould as I worked on this painting. I made about ten layers of different colors; the brush motions were translated from the music.

Dierdre Broussard, student work, 9" × 12" (22.9 cm × 30.5 cm)

Dierdre Broussard concentrated on maintaining a distinct direction to the flow of countless similar strokes of red, blue, and yellow. She began painting on wet paper, and as it dried, the marks became more focused. This progressive layering of dry over wet is a very logical way to form space; the eye perceives the less-defined strokes as farther away. Dierdre also did not apply each layer uniformly. The top right and bottom left corners are both remnants of earlier layers, while the left center area is densely populated with marks from each pass. Such distinctions further enhance the space in this exercise-turned-painting. Finally, the opaque Chinese white strokes on the right provide an effective counterpoint to the commanding direction of the flow, like a small pack of minnows suddenly darting out of a larger school.

Tanya Ruffin, student work, 9" × 12" (22.9 cm × 30.5 cm)

Tanya Ruffin has produced a dreamy, undulating world by keeping the paper wet throughout the process. We can detect some drier contrasting shapes among the prevalent puffy, cloudlike forms. Rather than let the paper dry completely as she painted, she occasionally rewet it, creating a lovely interplay between the soft but animated layers. The color further reflects this very soothing space by systematically moving along the color wheel from blue to purple to red.

Joe Holmes evokes a great sense of motion in his painting with two great elliptical movements that fill the top and bottom halves. Although a long, slashing stroke prevails, setting the rhythm, there are a number of contradictory marks that fly furiously about in this violent space. Obviously, Joe alternated great sweeping movements of his arm with smaller wrist and finger stroking. There are some abrupt changes of direction that also counter the big circular patterns. I can't help seeing imagery in these abstract wanderings, and this one reminds me of the depths of a tornado.

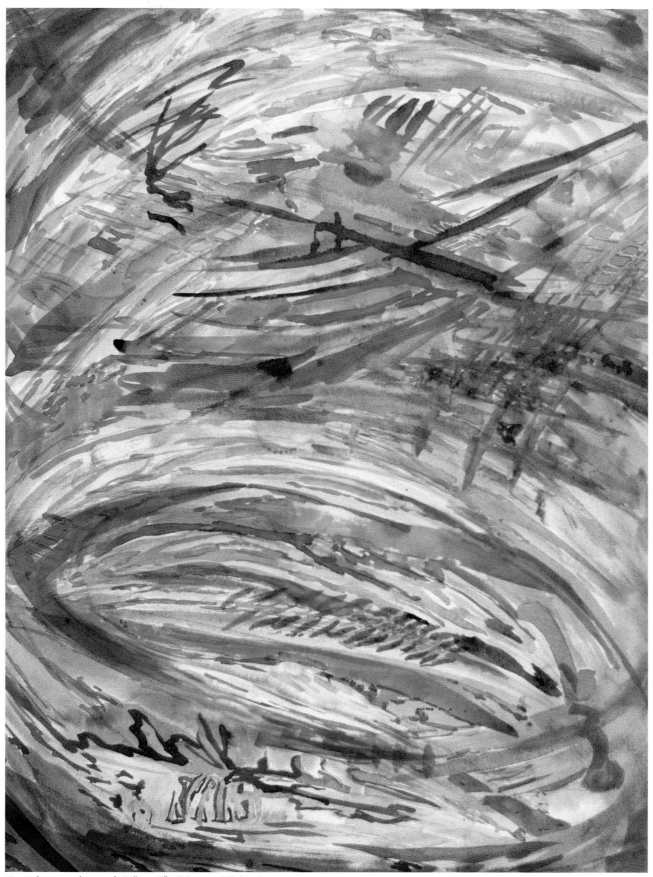

Joe Holmes, student work, 25" × 18" (63.5 cm × 45.7 cm)

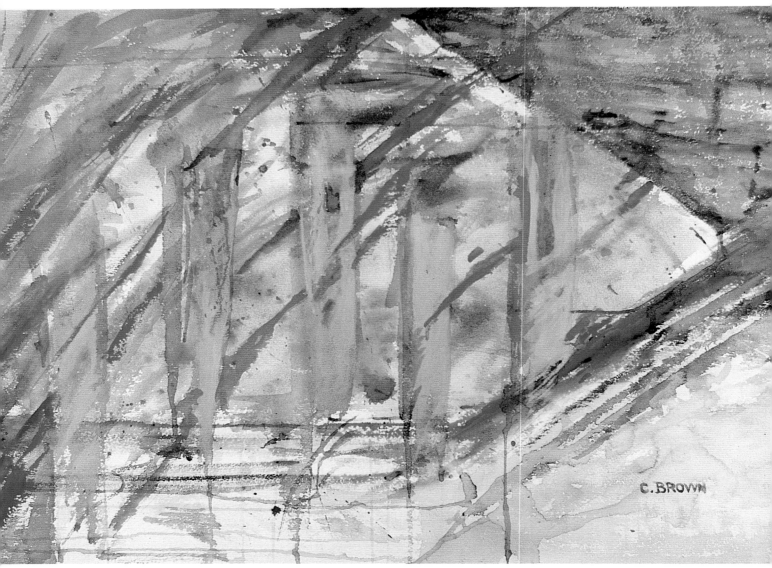

C. BROWN

Charles Brown, student work, 22" × 30" (55.9 cm × 76.2 cm)

Charles Brown volunteered the fact that he painted this while listening to the rock group Genesis. His meditations resulted in some relatively structured geometry housing the random scrapings of color, many of which are drybrush technique. He allowed a lot of paper to remain white during the process; this imparts a wonderful sense of light to the painting. Verticals, horizontals, and diagonals are clearly rendered and loosely woven together. Five mysterious yellow verticals dance in a well-orchestrated field of complementary colors.

Celeste Schexnaydre began with some very faint movements on very wet paper. Then she applied more color in big, splashing gestures that became more defined as the paper dried. She also made smaller notations within some of these large movements. Everything seems to be gently spilling from the right edge of the painting. Her final marks, the flora-like stems and lozenges at the top, seem almost recognizable, perhaps indicating that Celeste may have been thinking of some literal subject matter. Nonetheless, they add a little mystery and top the composition nicely.

Celeste Schexnaydre, student work, 16″ × 11″ (40.6 cm × 27.9 cm)

DAY 2
Edges

Honoré de Balzac's short story "The Hidden Masterpiece" contains many insights into painting and the creative process; I consider it required reading for any artist or art student. At one point in the story, the master painter Frenhofer lectures to the young Nicolas Poussin on the virtues of eliminating edges from forms, making it almost impossible to distinguish where an outline ends and the background begins. He contends that light alone gives appearance to form. The old painter concludes his inspired lesson by comparing this technique to that of the sun, which he names the divine painter of the universe.

Although the fictional Frenhofer could be satisfied with a single technique for handling edges, artists in the real world should explore all the possibilities. Variety in edge can produce different voices within a painting, changing the look of the space, controlling the tempo of the eye as it moves over the painted surface. You may choose to employ only one type of edge, as did Balzac's painter, or you may use many.

The painted statement will be different with each decision you make.

We will examine four different ways of handling edges. The hard edge gives absolute distinction to a form, while a soft, mingled edge suggests a more atmospheric look and lessens the focus. The overlapped transparent edge produces a third color that serves as the transitional element, and the linear edge marks a boundary that can vary as much as a line can be varied.

Exercise: Variety in Edges. Set up a still life of at least four objects. Make one painting from it that illustrates all four of the edge variations discussed. It is not necessary that you actually see the different edges in the setup, although varying surfaces and creative lighting can produce them. It is necessary that you paint them, either letting each object represent a different edge type or randomly weaving the different types throughout the painting.

Hard edges are produced by painting a shape, letting it dry, and carefully following its contour with the adjacent shapes or background. To save drying time and produce an even harder, sharper edge, you can leave a trace of unpainted white paper separating the edges. This will allow you to paint both edges at once without two shapes mingling.

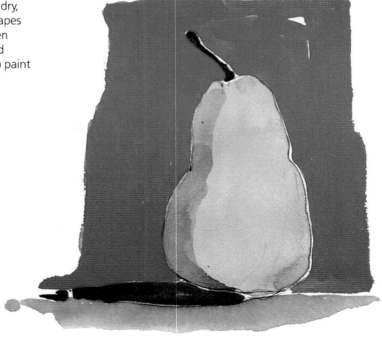

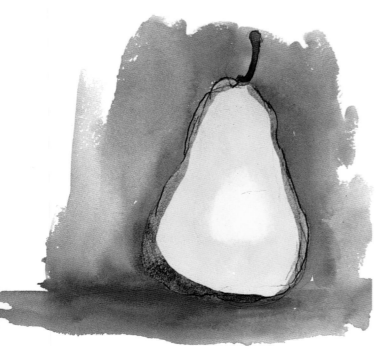

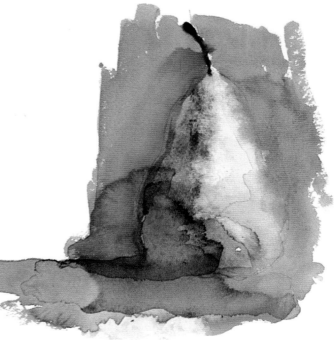

The overlapped transparent edge, a variation of the hard edge, is produced by painting a shape, letting it dry, and painting the background over it. In this illustration, the blue background has combined with the yellow of the pear to produce a green transitional edge.

Simple wet-in-wet technique will result in the soft, mingled edges that wed form to background. Color and value changes are used to distinguish the two.

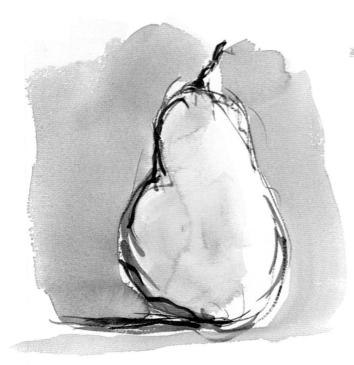

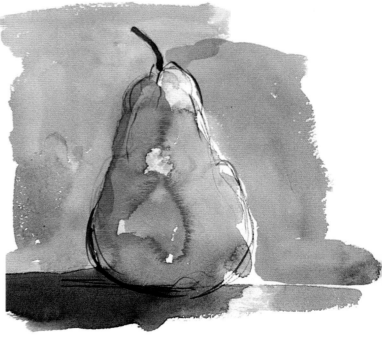

Here are a few of the many possible types of linear edges. The pear's shape was first constructed with line, followed by the broad planes of color. The character and function of the edges are determined by the type of line painted. In this example, they are thin and frilly in the light, heavy and morose in the shadows.

All four types of edges—the hard edge, the overlapped transparent edge, the mingled edge, and the linear edge—were used to define the perimeter of this pear's form.

DAY 2: Edges

Steve Erickson has succeeded in producing a very cohesive space despite his scattering of the various techniques here and there. He finds linear edges in the metallic coffeepot and the piece of drapery entering the foreground. Soft edges dominate the two objects in the left background, contrasting with the hard edges of the three foreground objects—a fine example of how varying the edges helps promote spatial illusion. The orange and the large blue vase both contain overlapped transparent edges. An ambiguous brown plane connects the coffeepot to the big blue vase, overlapping the edges of both. This idiosyncratic mark provides yet another beautiful surprise in a painting chock full of them.

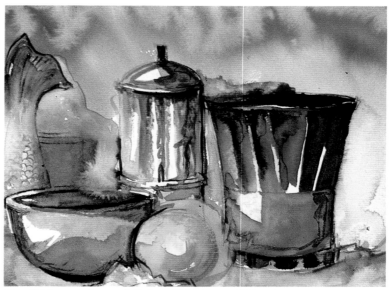

Steve Erickson, student work, 9½" × 13" (24.1 cm × 33.0 cm)

Ann Mouser accents a predominantly soft space with hard and linear edges. She has casually shifted edge techniques in each object, so the various types are evenly dispersed, except in the espresso pot. There, the hard stripes and assertive line make it the center of attention. Note the exceptional molding of shadows in the rich green ground plane and the wet-in-wet mingling of the complements blue and orange in the background. Drenching color and value produce the pleasant light, but Ann's preoccupation with the edges imparts the vitality that I feel is this painting's strongest asset.

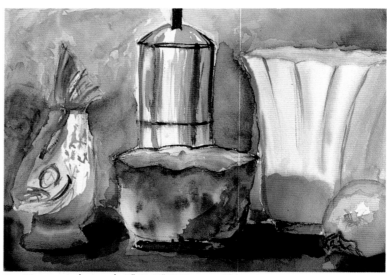

Ann Mouser, student work, 11" × 15" (27.9 cm × 38.1 cm)

Robin Viallon achieves a heightened sense of space, suitable to his personal style of draftsmanship, by using a different edge type for each object of this still life. The fish vase is constructed with linear edges, the coffeepot with hard and linear, the bowl with soft, the big vase with overlapped and soft. The orange flaunts all four edge types; its varying contour, the warmth and intensity of its color, and its front-and-center placement all assert its dominance in the composition.

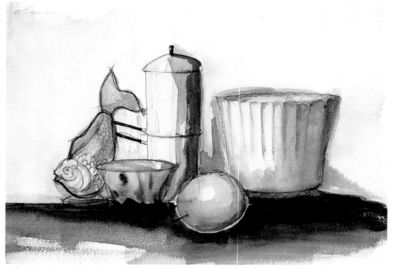

Robin Viallon, student work, 12" × 16" (30.5 cm × 40.6 cm)

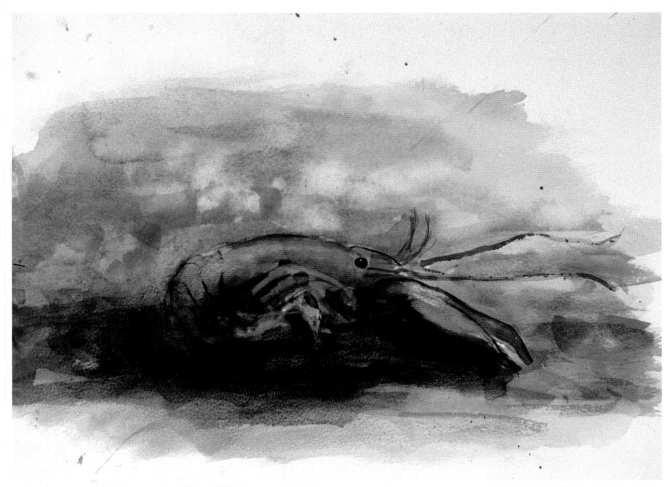

Michael Crespo, MUDBUG, watercolor, 11″ × 15″ (27.9 cm × 38.1 cm)

I suppose that painting and eating crawfish could be vocation enough in one person's life. This book was being formed while the delectable crustaceans were in full bloom, which accounts for their appearance in a couple of my paintings. I intended that this specimen be painted in a submerged environment, a bayou of course. I accomplished this by using all four edge types to construct the creature. There are hard edges in his legs and on his back; overlapped transparent edges under his tail and in the background; linear edges distinguishing parts of the anatomy, especially the segmented tail; and soft, mingled edges scattered throughout. This dispersal of edges causes focus to move in and out, which definitely enhances the illusion that he is underwater.

Maureen Barnes surrounds areas of soft, damp brushwork with hard edges that bring a lively feeling to a quietly glowing still life. When painting edges, you might consider their relationship to the planes that they border. For example, the dark, elliptical shadows cast on the ground plane are hard, flat planes with hard edges; the other shapes are painted in various degrees of wet-in-wet but still have hard edges. A single type of edge can play numerous roles in combination with various techniques.

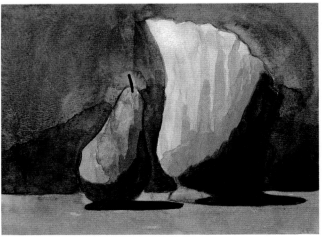

Maureen Barnes, student work, 9″ × 12″ (22.9 cm × 30.5 cm)

Patricia Burke has fused three of the edge types to produce the sinuous surface of this study of bananas and grapes. The grapes are formed with hard and soft edges that seem to pop in and out of the paper. The bananas are dominated by soft edges occasionally marked with line, a line that further articulates the space by its cadence from sharp and dark to dull and flat. Remember that linear edges can be manipulated with all the qualities attributed to line: width, value, color, and emotion.

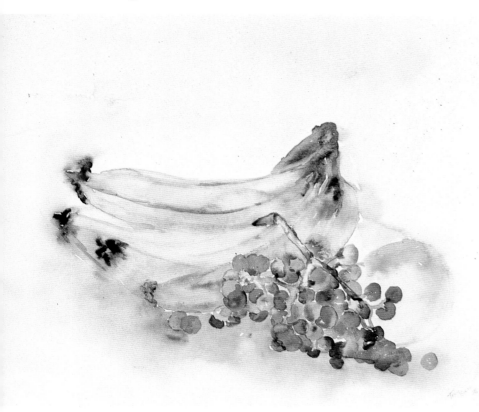

Patricia Burke, student work, 15″ × 20″ (38.1 cm × 50.8 cm)

Robert Hausey relies heavily on contrasting edges to construct the space of his vegetarian still life; he uses hard edges in the background and soft edges in the foreground. Thus, he describes the volumes of the turnip and lemons with soft-edged transitions of light that are echoed in the play of light on the tabletop. In the background, he describes the bunches of parsley with clear contours and many small, discrete, hard-edged planes.

Robert does vary this scheme somewhat for the sake of unity and balance. There are some soft edges in the background parsley, and the contours of the lemons and turnip are sharply defined. He is keenly aware of the potential of edges within a composition, and he paints them with dazzling skill.

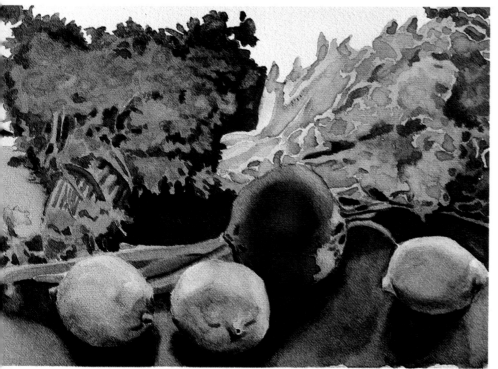

Robert Hausey, STILL LIFE WITH LEMONS, PARSLEY, AND TURNIP, watercolor, 8½″ × 11″ (21.6 cm × 27.9 cm)

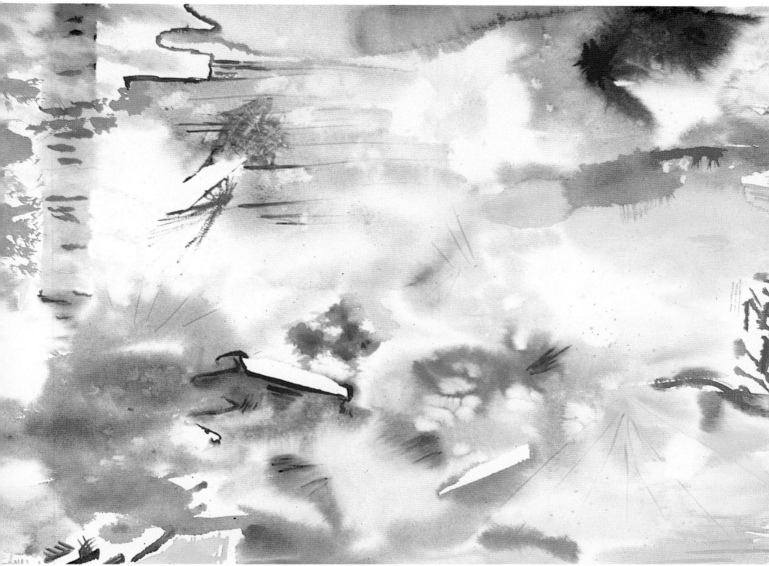

Laure Henry, student work, 16" × 22" (40.6 cm × 55.9 cm)

Laure Henry has paid attention to edges in this abstraction from a landscape. The subject's identity is lost in the wet, mingled edges and the bright primary colors. Contrasting sharp, linear edges move the eye around the space and vaguely describe trees, foliage, and architectural forms. The side of the blue tree trunk on the left displays alternating mingled and hard-edge techniques. Other edges in this painting have been formed by overlaying wet edges over hard edges, forming another variation on the overlapped transparent technique.

DAY 3
Multiple Viewpoints

One of the most basic problems painters must wrestle with is describing a three-dimensional world in a two-dimensional medium. From the Renaissance through the early part of this century, most artists relied on one- and two-point perspective. Then Pablo Picasso, Georges Braque, and the other artists we now call the cubists started exploring alternatives; one technique they used was to paint a subject from several different angles at the same time, using multiple points of view in the same painting.

Picasso argued that his work was more realistic than that of the academic painters because their subjects were all painted from a single point of view, while he drew his from above, below, right, and left, displaying all these facets simultaneously. He supplied the viewer with more information about the subject. His argument, however cheeky, was essentially correct, and although his paintings distorted nature, they resulted from intense analysis and perception. Picasso and the cubists completely restructured the space of the "real world" on which they gazed so fiercely.

Today I would like you to generate a new vision of nature, not by whim of the imagination, but by a methodical examination of the subject. You will also make a painting using multiple viewpoints to produce more credible volumes.

Exercise: Shifting the Viewpoint. For the first painting, set up a still life with five or more objects. Place them out in the middle of the room rather than against a wall. There should be plenty of activity in your field of vision. With a pencil, or with a small brush and paint, lightly sketch the entire still life, including what you see behind it. Now shift your point of view, right or left, up or down, and draw the

setup again, right over the first sketch. Notice how the shapes and dimensions of the objects change as you move. Continue to move and draw in this manner three more times, making a total of five points of view overlaid on the paper. By now the references to objects will be greatly distorted, so be aware as you paint that new shapes and new rhythms have been created. You may choose to work with a new color system, or you may work in local color. Combine some of the shapes into new, larger ones to vary the scale. You may wish to paint with a natural light in mind, perhaps, illuminating the scene from the right and leaving darker values on the left of the "new" objects. Experiment with technique. Transparent overlays are effective in rendering the new space. Whatever you do, do not get tongue-tied trying to follow the still life too closely. You have discovered a new world; keep experimenting and innovating until the painting is finished.

Exercise: Increasing Volume with Multiple Viewpoints. For the second painting, work from one object, perhaps a piece of fruit, placed in a very simple setting. Make a pencil sketch of the object in the space. Now shift your viewpoint very slightly, not radically as you may have in the first problem, and overlay another drawing from this new point of view. Do not redraw the space this time, only the object. Repeat this for a total of three drawings on the paper. Paint the object as you observe it. Be subtle in painting the added planes. The goal in this painting is to produce a slightly distorted object, smoothly bulging and full. In future paintings, you can achieve the same results by simply shifting your head and looking around the forms you paint to discover the extra bit that will augment fullness and weight.

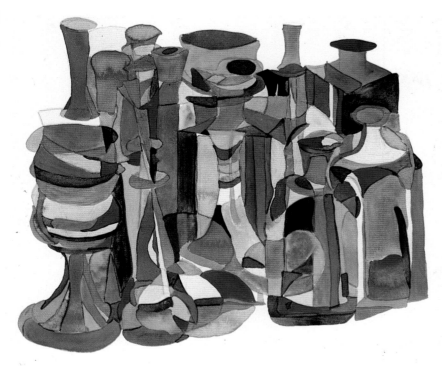

Celeste Schexnaydre, student work, 11" × 15" (27.9 cm × 38.1 cm)

As the eye wanders about this complicated accumulation of multiple viewpoints, it comes to rest on the objects in the far background at the top of the painting. Here, Celeste Schexnaydre has simplified her discoveries and made subtle references to the original shapes of some of the objects she painted. They provide a comfortable backdrop for the frenzy of shapes before them. But even in this frenzy we can still discern some of the original contours. The forms are all exploded, but Celeste has managed to secure their original positions by using repeated verticals. She has also toyed with the edges of the paper by keeping the objects together on the stark white field, their commanding, jagged contour forming a new perimeter.

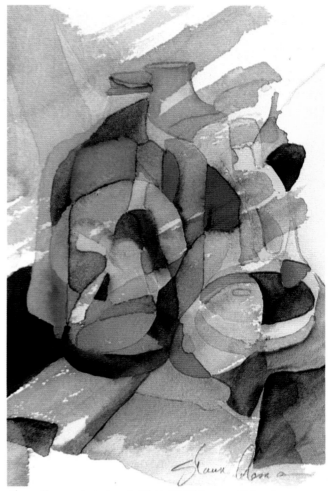

Shaun Aleman has incorporated the table and background into his painting and has used transparencies to record his shifts in viewpoint. He began by laying in the blue underpainting, which resulted from fragmenting the surrounding space. As he moved and viewed the changing space, he recorded only select planes suggested by the objects, clustering the smaller shapes in the center, letting the larger ones surround them, maintaining the integrity of the original group of objects. He varied the edges: some wet-in-wet, some wet-on-dry. The color temperature varies from one extreme to the other, with warmer colors patterned effectively across the cool bluish field.

Shaun Aleman, student work, 11" × 17" (27.9 cm × 17.8 cm)

DAY 3: Multiple Viewpoints

Robin Viallon uses color to simplify the complex drawing he initially made. You can see where he disregarded some of the new shapes he discovered and returned to the original objects, leaving a curious and effective interplay between pencil line and paint. This is especially true of the fruit in the center, which, although still very planar, most resembles the perceived object. Most of Robin's newly constructed objects still suggest very credible volumes despite the explosion and distortion of their forms. He ties the setup nicely to the ground plane with faint dustings of paint along the bottom edges—just enough transition to relate the mass to the white of the paper.

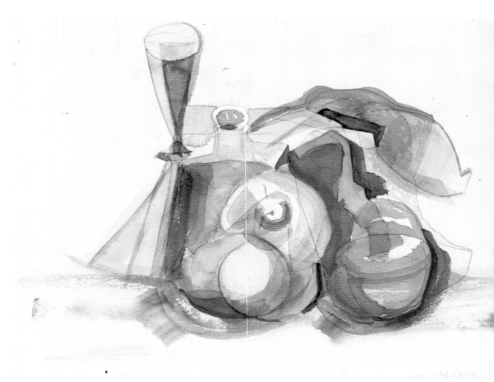

Robin Viallon, student work, 11" × 15" (27.9 cm × 38.1 cm)

Maureen Barnes has flattened the space considerably in her painting by letting some of the forms run off the page. White shapes are trapped across the top of the painting and become constituents of the mass and not just surrounding space. Remember—when shapes are cropped or placed very close to the edges of the format, the background or foreground will break up into shapes and look less like a field. So if you want more interplay of shapes, fill the page with subject.

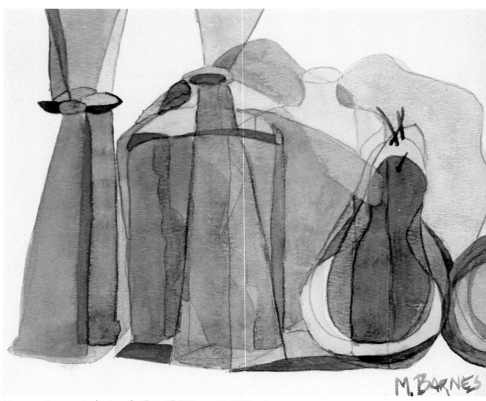

Maureen Barnes, student work, 7" × 9" (17.8 cm × 22.9 cm)

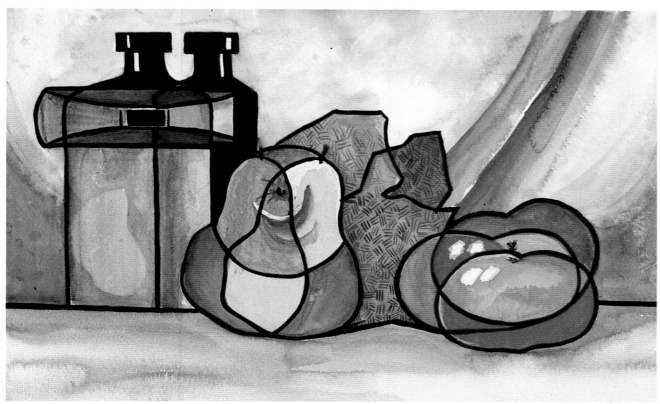

Steve Erickson, student work, 10" × 17" (25.4 cm × 43.2 cm)

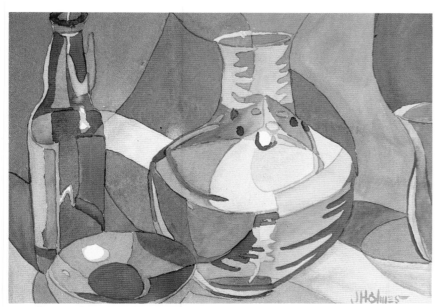

Joe Holmes, student work, 9" × 13" (22.9 cm × 33.0 cm)

Steve Erickson has produced a variation on the problem, painting the environment from one point of view and the objects from many. The juxtaposition is impressive, and I encourage you to experiment with this problem if you wish, but I feel this painting would not have been as successful if he had not been inspired to run the black line through the setup. It further distorts the objects as well as isolating and strengthening the colors, much as the lead does in stained glass. Notice his deliberate textural detailing on the fruit and especially the sponge in the background. This kind of symbolic description was also favored by the cubists.

In this painting, Joe Holmes retains the basic contours of his objects, but he sets their interiors and the surrounding space spinning with shapes he captured while moving his point of view. He has corralled small shapes and bright colors in the objects that contrast in scale and color with the background. It's curious that while these distorted shapes fill the objects with a tension that is on the verge of exploding, they also describe the natural surfaces and volumes.

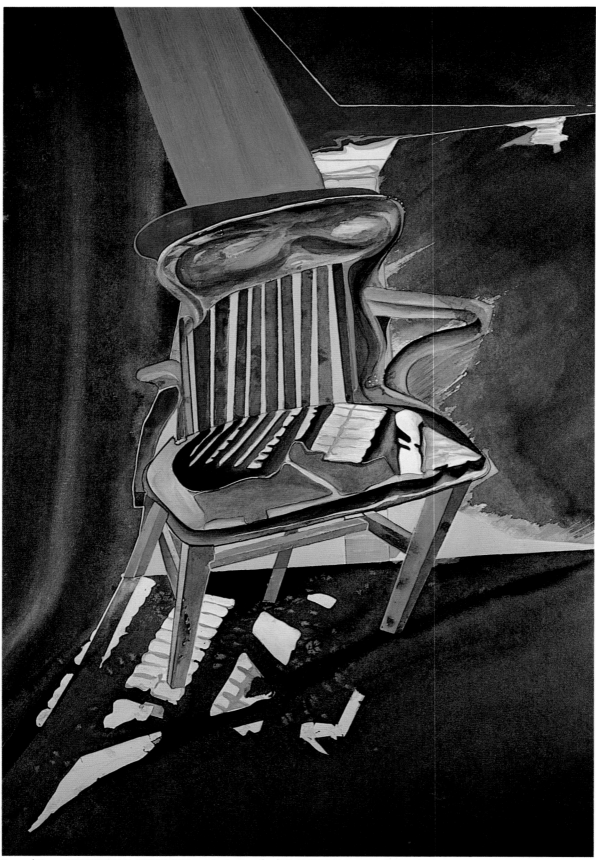

Samuel Corso, NIGHT VISION: CHAIR RIDE, sumi-e/watercolor, 40″ × 27″ (101.6 cm × 68.6 cm)

This is my rendition of the second part of this problem. An eggplant is usually a very smooth object, but in my painting it takes on a lumpier appearance. This results from my shifting positions a couple of times to "see around" the form so I could exaggerate its volume. My initial drawing was much more distorted. I always feel it is best to shoot beyond your mark, then pull back a little. I used the paint to veil some of the increased planar activity, but the extra planes are still noticeable—the depression and bulge at the bottom right of the vegetable, for example. Granted, the eggplant is somewhat distorted, but its form is full and heavy, and that is what you get when you paint a bit more than you see.

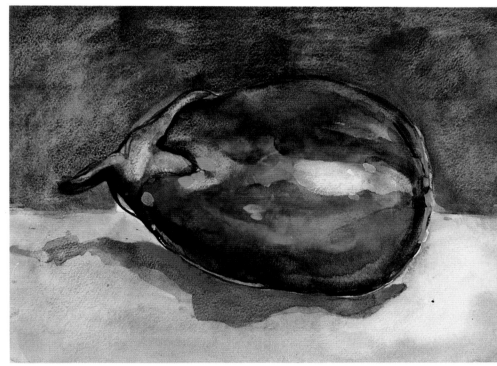

Michael Crespo, EGGPLANT, watercolor, 11″ × 15″ (27.9 cm × 38.1 cm)

Joe Holmes's use of multiple viewpoints has produced an illusion of great depth from the spoon in the bowl to the chair in the back. As we look from object to object, the change of viewpoint slows us down, making the journey to the back of the painting seem like a long one. As we look at each object individually, we find clues to Joe's moving position: the handle of the cup as compared to its rim, the top of the coffeepot as compared to the bottom, the way the back of the bowl mysteriously lifts up. These distortions, coupled with some very clear planar rendering, produce objects that sit on the table with the weight of lead balloons. The high-key color and the bath of light also contribute to the success of this painting.

Like the objects in Joe Holmes's painting, this chair has been blown apart and reassembled. As you look at each part of it, you can feel yourself in a different position in the room. Distortion has breathed motion into the usually static form, and the chair seems about to gnash its way through the wall and into the light. The background is also alive with beautifully controlled washes interrupted by the harsh light below and the geometry above.

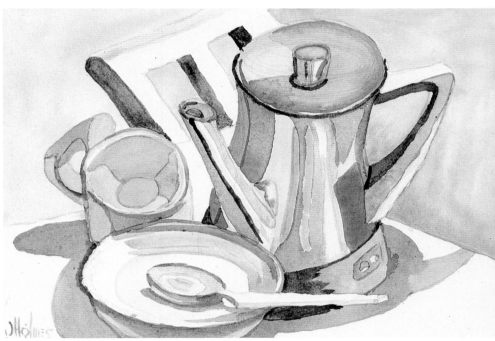

Joe Holmes, student work, 8″ × 11½″ (20.3 cm × 29.2 cm)

DAY 4
Self-Portrait

The self-portrait is, aside from the nude, one of the most popular subjects in painting; furthermore, you yourself are the most readily available model. Today you will do three paintings exploring various aspects of the self-portrait. You will need a mirror and some kind of light source, preferably natural light from a window. Before painting each phase of the problem, do some pencil sketches so you will be comfortable with this sometimes intimidating subject.

Exercise: Seeing the Planes. First, examine your head for what it is visually—a sphere with an undulating surface of planes. Look at your head in the mirror and paint from it, grossly exaggerating the planar structure. Begin with the obvious: the fore-head, cheeks, nose, and sides and top of the head. Then look for the smaller planes that make up the eyes, nose, ears, and other features. Feel free to overstate and invent new planes. You may have to make certain transitions. Change color or value as you move from plane to plane to keep them distinct. As you paint, feel with your hand the part of your head you're painting. Light exposes most of the planes, but your hand can show you those hidden beneath the surface.

Exercise: Close-up of the Face. In the second painting, depict only the features of the face, cram-ming them into the format of the paper. As you work on this one, place your mirror as near as you can to your face. Paint your eyes, nose, and mouth as you see them, paying close attention to the details of their structure. It is not necessary to exaggerate the planes as in the first painting, but keep the planar construction in mind. Fill the page with your face, letting the edges of the paper crop off any other parts of the head.

Exercise: Narrative Self-Portrait. Finally, you will investigate a more narrative, or storytelling, composi-tion that includes your self-portrait. Make a painting that contains your head and one of your hands. What your hand is doing will determine how dramatic a tale you tell. Also consider attempting some facial

expression, whether it be one of anger, joy, or simple disinterest. Be sure to investigate this carefully with your pencil beforehand. The hand and the expression may provide a little more of a challenge.

Caution: Any system of colors can produce flesh tones. Although the standard pinkish variety may work well for you, do not assume it's the only way. As always, experiment.

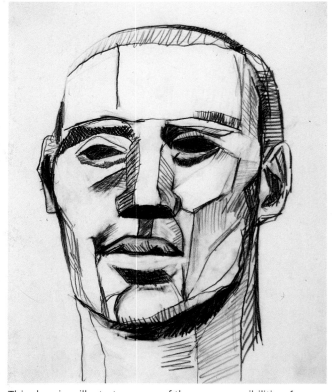

This drawing illustrates some of the many possibilities for constructing the planes of the head. Notice that it contains both open and closed planes. A closed plane is one that is completely surrounded by a continuous line. The shadow under the nose, the top lip, and the shadow under the bottom lip are examples of closed planes. An open plane is not completely enclosed but bleeds into another plane at some point. The plane of the left cheek flows into the vertical plane moving down to the neck, as well as the plane surrounding the eye and the plane under the left side of the nose. These are all open planes. In fact, the left side of the face is constructed with predominantly open planes, while closed planes prevail on the right side.

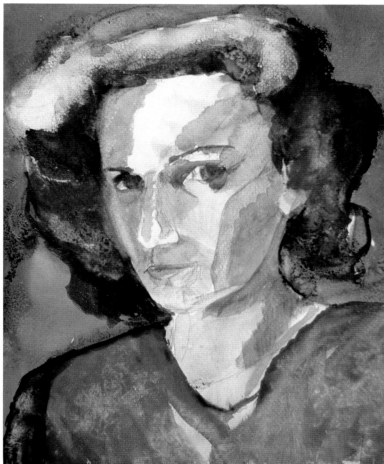

Alice Verberne, student work, 12½" × 10" (31.7 cm × 25.4 cm)

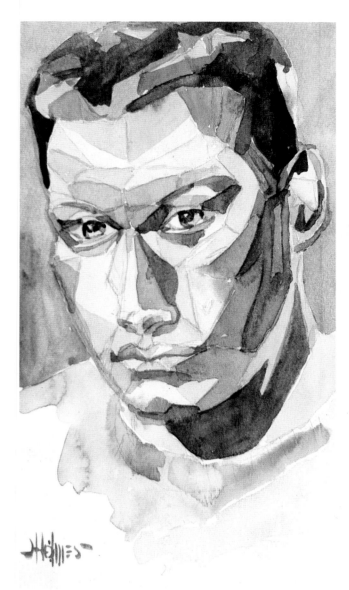

Joe Holmes, student work, 12" × 6" (30.5 cm × 15.2 cm)

Joe Holmes has chosen an analogous palette ranging from violet to blue-green to render the planes of his head. These closely related colors make the transition across the exaggerated planes a lot smoother. On the nose, neck, and top of the head he has used a warm orange to accent the dominant cool colors. His placement of values works well in giving the whole head a greater sense of volume. Where he wants a plane to come forward, he leaves white paper or applies a very faint color. When he traps a light value deeper in the space—the light plane under the right cheek, for example—it becomes a plane of reflected light.

The illusion is enhanced by the variation in the sizes of the planes, from the larger ones in the shirt and neck to the smallest in the detailed construction of the eyes. Note also the various techniques within the planes: Some are flat, some modeled, some textured.

Alice Verberne approaches the problem by drawing much larger, more generalized planes; however, her lush technique loads the simple planes with visual interest. The most successful area is the hair, where soft edges create smooth transitions between the articulate planes. See how she just overlays a transparent red to establish a new plane. Once again, a well-controlled value system defines the placement of forms, with planes dramatically changing from light to dark as they move from front to back. This is especially necessary if you plan to use a lot of subtle wet-in-wet planes.

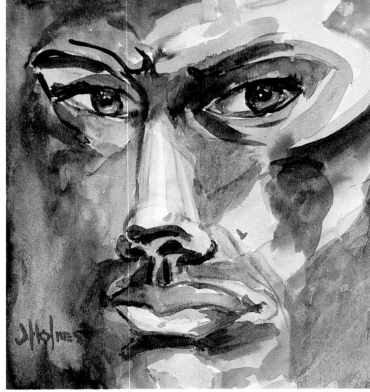

Joe Holmes, student work, 11½" × 12" (29.2 cm × 30.5 cm)

Joe Holmes used the complementary colors blue and orange, applied wet-in-wet, as the basis for his second self-portrait. Then he used drier strokes to develop the features into a disturbing, ominous stare. The distortion of the face melting to the edges of the page adds to the intensity of his expression.

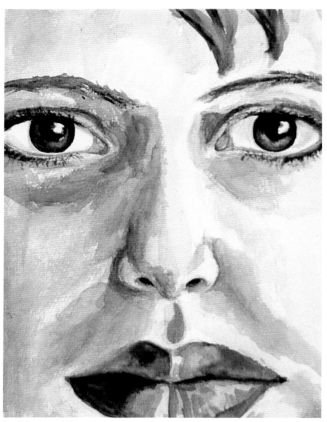

Madeline Terrell, student work, 8½" × 11" (21.6 cm × 27.9 cm)

Here's a face that is just bordering on a smile. These subtle expressions are often more difficult to depict than the more obvious ones. Do try to make some theatrical facial gesture in at least one of the three self-portraits.

Madeline Terrell chose a monochromatic gray and a lifelike rendering technique to make this painting, which looks a little like a snapshot. She creates a distinct scale distortion by pressing her features right up to the viewer's face, like Gulliver peering through a Lilliputian picture window.

Scot Guidry cheats a little and lets a sliver of blue background define one side of his head, but this is still in keeping with the basic premise of experimenting with the edges of the format. The blue not only works as a foil to the pale, watery color and paper-white that define the other edges, but also serves as a complement to the subtle orange hues that define the face.

Using multiple viewpoints, Scot looks around the left side of the face, exposing planes that are not usually visible in the three-quarter view. He sets up tension on that side by enlarging the left eye so much that the entire left side of the face seems to be trying to jump out in front, but the nose is constructed strongly enough to keep it in place.

Paul Cézanne sometimes painted the eyes two different sizes. The theory is that if the eyes are different, the viewer will spend equal time looking at each, moving back and forth and thus creating the illusion of space. If the eyes were identical, we would view them simultaneously as a unit, which would flatten out the space. The theory is illustrated well in this expressive piece.

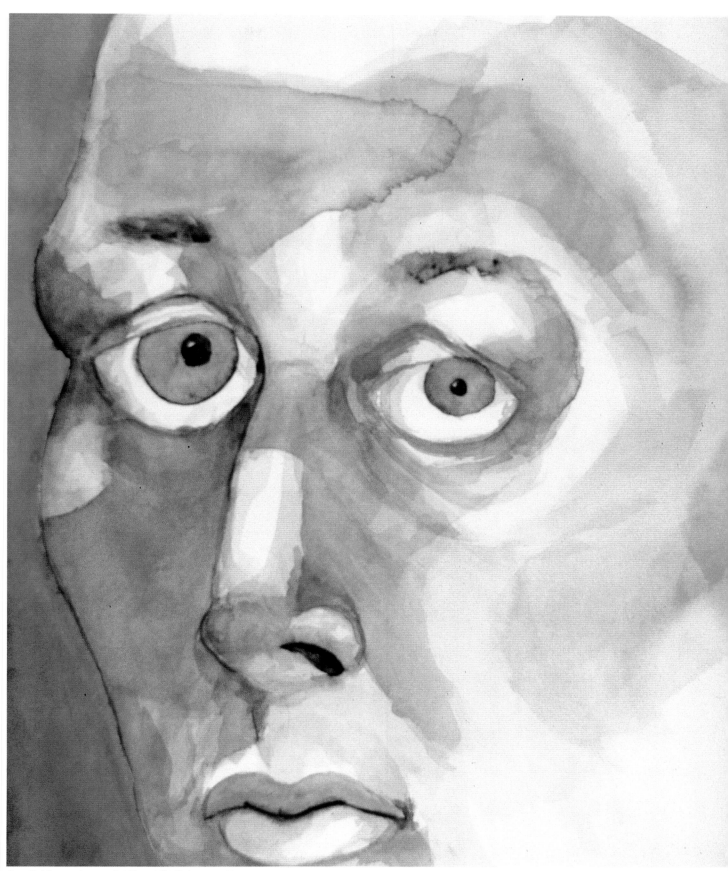

Scot Guidry, student work, 16″ × 13″ (40.6 cm × 33.0 cm)

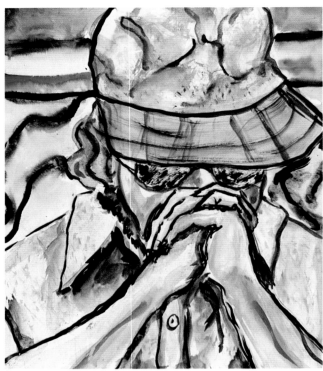

Amy Karns, student work, 17" × 15" (43.2 cm × 38.1 cm)

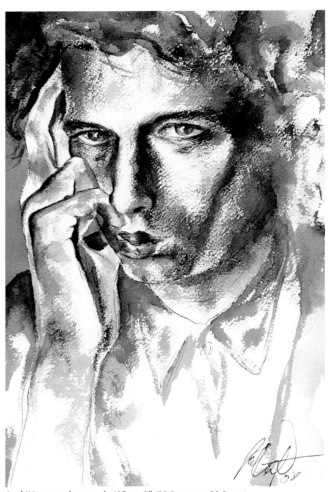

Joel West, student work, 13" × 9" (33.0 cm × 22.9 cm)

Joel West uses a drybrush technique over a wetter under-painting for his self-portrait with hand. He has carefully modeled the planes, which are smooth and distinct. The flurrying hair makes a fine frame for the contrasting planes of flesh. He has painted the hand in a different gray than the face it touches, probably to call attention to the narrative event. The hard edges and sharp value contrasts also draw the viewer's eye to this area. Notice how he chose to distort the cheek on the right, creating an entirely new plane in the face. We're always more willing to take liberties when painting self-portraits. You probably couldn't get away with such a distortion in a commissioned portrait or a painting of a relative.

Amy Karns's hands mask her self-portrait from the viewer. She uses a heavy, rambling black line that contrasts with the wisps of color that illuminate this funky painting. There is some delicate textural work in the hat and shirt that hints at decorative designs. Note how some of the black lines bleed, helping to establish contours in adjacent planes; this effect is achieved by laying down the line and then passing over it with a brush loaded with clean water. Amy alternates this melting line with a sharp, vivid line that focuses and softens the general space. The expressive rendering of the hands gives them the appearance of meshing together, knuckles white.

Alice Verberne evokes an unearthly light and makes a corresponding gesture of the hand in this furiously painted work. I asked that a narrative be explored, and she certainly answered that challenge. The many-layered spectrum of colors and techniques transforms the simple self-portrait into a dramatic enigma. She sanded areas of the paper prior to painting and sprinkled salt into most of the wet areas. I am particularly fond of how she changed the nature of the hair from one side of the face to the other. The right side is muted by wet washes of a grainy manganese blue, while the left side sparkles with strong values and built-up strokes. The finished work is a rich pool of painting techniques.

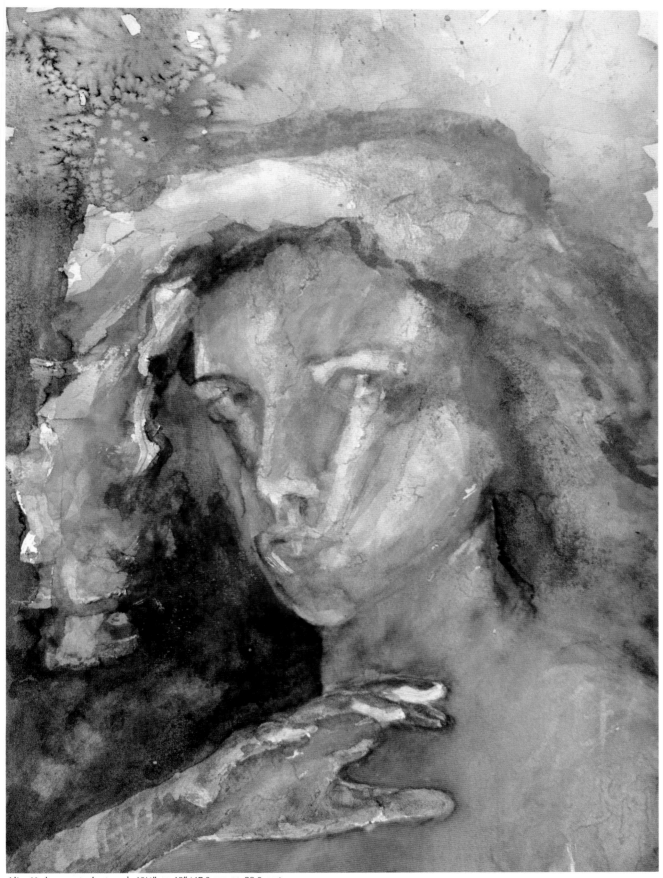

Alice Verberne, student work, 18½″ × 13″ (47.0 cm × 33.0 cm)

DAY 5
Drapery Anatomy

Drapery clothes, adorns, cleans, and dries our bodies; cradles our sleep; covers our tables; regulates the light in our rooms; sails our boats; and flies as banner and flag. And because we paint all of this and more, it's small wonder that so many artists have dwelled, both in sketch and in finished work, on folds of cloth in action and at rest. The simple measure of fabric has even become a motif itself, carefully arranged and placed in countless still-life paintings.

Drapery is not difficult to paint when it simply describes the form it covers, but when it also presents a maze of entangled folds, even the seasoned painter may balk or sigh with frustration. Let's begin by learning how to paint the basic anatomy of a drapery fold. Once we understand that, it will be easier to plot its complicated wanderings and embellish it with more detail.

Every fold has three surfaces protruding from a base: top, right side, and left side. The top plane will be left paper-white, as it reflects the most light. The sides should be painted a middle gray value, and the base dark gray (but not black). When a fold drops to one side or is viewed from an angle, it is said to be undercut. On one side, the top plane is viewed directly against the base; the side plane is no longer visible. A very dark, even black, value painted against the paper-white edge of the top plane and graduated to a lighter value from the fold out will imply that the side is tucked under, or undercut.

Exercise: Basic Folds. To practice painting the basic folds, attach a piece of white or near-white cloth to the wall, using tacks in strategic positions to make horizontal, vertical, and diagonal folds. To underscore the basic nature of the problem, try to mold the cloth into simple folds. Light it well, exposing the folds as dramatically as possible. As you sketch on your paper, or begin to paint directly, let the drapery fill the format to the edges. The painting should be filled with folds. Paint monochromatically, that is, in one color (a gray will look more natural), and follow the value system mentioned above. Remember to keep it simple, and remember to look for the undercut folds. Also, a basic two-sided fold can go for a distance and suddenly flop over with an undercut. You may use any technique you wish; it's the value placement that is important.

Exercise: Patterned Drapery. For the second part of this problem, pin up a patterned drapery on the wall. Again, compose your painting so the fabric fills the page; this time, use a full range of color. Although the basic fold structure still applies here, patterned draperies, with their lines, rhythms, shapes, and colors, elicit more varied and expressive responses. For example, the linear perspective of the pattern itself will describe a fold with no value changes whatsoever; different hues used inventively will wander in and out of the picture plane, delineating the hills and valleys of the folds. Feel free to search and express more with this painting.

Obviously this is not the only procedure for painting drapery; sometimes a few swats of the brush will effectively explain a bundle of cloth. But this rudimentary structuring will help you see and explain the most tediously posed fabric.

Your study of drapery should continue beyond today's lesson. Different weights and surfaces of materials provide endless variation in texture, not to mention pattern.

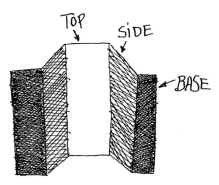

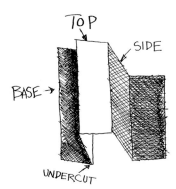

We can see both sides of the protrusion in this basic fold. The top is white, the sides gray, and the base dark, but not black. Sketching these diagrams will help you understand this form.

An undercut fold flops over, obscuring one side; the black base lies right next to the white top of the fold. On the other side, the value darkens gradually from the top to the base.

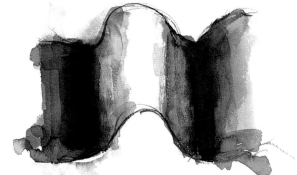

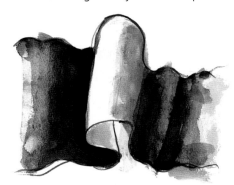

Here is a painted version of the basic fold. Although watercolor can produce many little aberrations in the paint surface, the value system follows the same scheme.

Here is a painted version of the undercut fold. Notice the amount of color that can be applied without hampering the effects of the value changes.

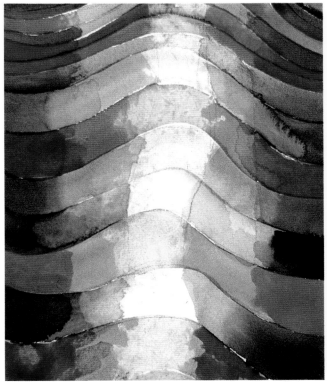

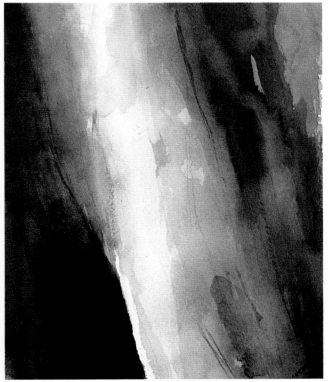

Here is a basic fold in a striped cloth. The perspective of the horizontal lines of the cloth does as much to indicate the peak and valleys of the fold as do the value gradations.

Just below the center of this painting, the basic fold abruptly becomes undercut. The undercut is emphasized by the extreme dark abutting the paper-white line at bottom center.

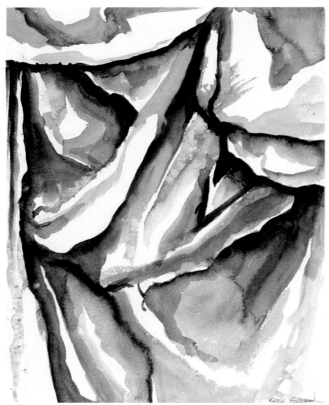

Steve Erickson, student work, 14″ × 11″ (35.6 cm × 27.9 cm)

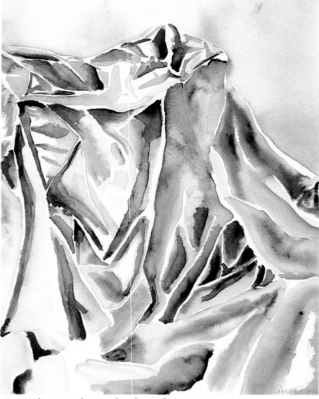

Amy Holmes, student work, 14″ × 11″ (35.6 cm × 27.9 cm)

Steve Erickson has followed the formula closely, using a gray composed of blue and sienna. He lightened his value scheme somewhat in the folds in the lower right corner and across the top; they play second fiddle to the more rigorously rendered folds of the center. As I am always reminding you, hierarchies of dominance create space.

This drapery could easily masquerade as a mountain peak. Amy Holmes has rendered the deep pockets with dark shapes that move up the sides to sharp, white, linear, narrow peaks. She rendered the larger folds with wet-in-wet technique. This is a complicated setup, but Amy has tamed it with basic anatomy without losing the intricacy of the forms.

Dierdre Broussard presents both problems in a single painting, a diptych. In the monochromatic study, she reversed the value system that I suggested. I heartily support any deviations from my teaching, especially if they work. Who am I to argue with success? The tops of her simple folds are a middle value, the sides dark, and the base white. There may be small discrepancies in her ephemeral rendering, but the effect is fine.

The folds in the patterned drape are not as clear, but some broad planes of fabric are indicated by areas of different values and color intensity. The darker, more vibrant areas come forward over the milky, grayed surroundings.

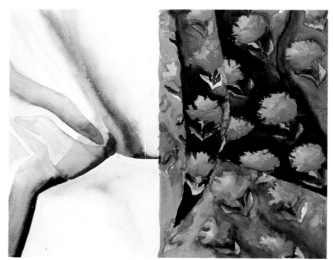

Dierdre Broussard, student work, 11″ × 14″ (27.9 cm × 35.6 cm)

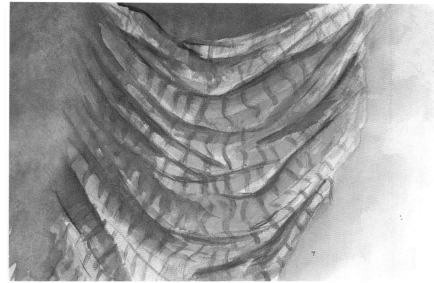

Eloisa Higgins lit her lines of folds from the lower right for a stunning effect that she has rendered convincingly in blue and red-violet. For the most part, she has used the basic formulas, including both basic folds and undercuts. She indicated the folds with variations in value and then reiterated them with the striped pattern of the drapes. The dark, smoky area on the left is beautifully painted.

Eloisa Higgins, student work, 7½″ × 11″ (19.1 cm × 27.4 cm)

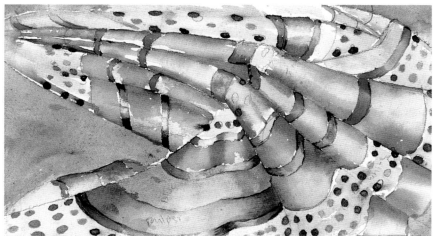

Marvin Carter laid out his drape on a table and then painted its folds in a highly stylized manner, making them look almost like shiny metal tubes. His manipulation of the pattern is excellent: Where the value changes on the fold, the value of the pattern changes as well. Too many times this is overlooked and the pattern contradicts the light source. Marvin has also made use of a controlled linear perspective system: The folds diminish as they vanish to the left corner, much like an unfurled fan.

Marvin Carter, student work, 6″ × 10½″ (15.2 cm × 26.7 cm)

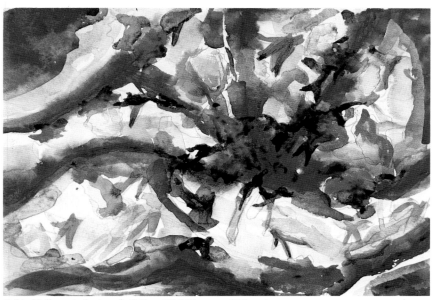

I offered you the option of taking liberties with this pattern painting, and Robin Viallon did just that, making a drapery study into an energetic abstraction. But if he painted three lemons in front of it, it would immediately be transformed into a hanging drapery background like those of Henri Matisse. Come to think of it, I strongly advise you to research Matisse's paintings; they contain innumerable lessons in painting patterned drapes. I've placed Robin in exalted company, but I do think his exercise exudes great spirit in its vigorous markings and pure colors.

Robin Viallon, student work, 7½″ × 11″ (19.1 cm × 27.9 cm)

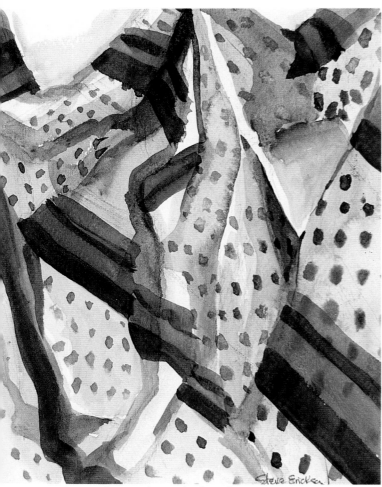

Steve Erickson, student work, 11" × 9" (27.9 cm × 22.9 cm)

Steve Erickson began constructing this patterned drapery by painting the folds in a neutral gray color without the pattern. After letting it dry, he worked the yellow, blue, and violet of the pattern over the underpainting. The values of the folds are seen through the transparent colors, uniting them with the contour of the drape. The fabric was intricately folded so the striped motif was broken up and dispersed across the page, resulting in a good compositional patterning.

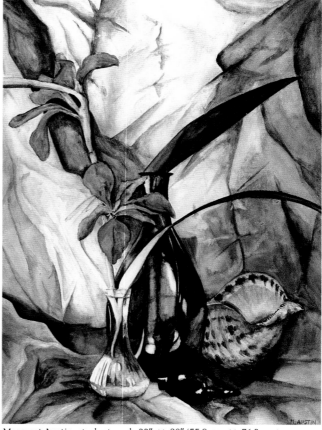

Margaret Austin, student work, 22" × 30" (55.9 cm × 76.2 cm)

Drapery dominates the space in this fine painting by Margaret Austin. She has painstakingly rendered the drape in a very personal matter, its jagged contours echoing the linear movements in the objects it engulfs. She applied textured washes to areas that fall into shadow. A shower of light from above flows down over the surface of the cloth, illuminating the leaves of the iris and sparkling in sharp highlights on the dark green bottle. For me, this fabric is intense and magical, leaping back and forth between two roles, flowing drape and rocky crevice.

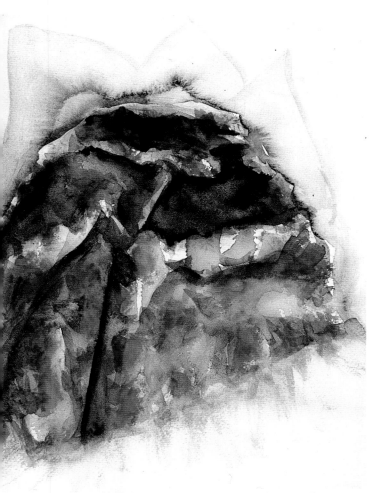

Mohd. Salim Hassan, student work, 15″ × 9″ (38.1 cm × 22.9 cm)

Salim Hassan has worked his drapery study on wet paper, producing a dynamic mass of soft edges and colors that bleed together. Here is a good example of an innovative approach to painting drapery. If you saw this painting out of context, you might not recognize it as cloth, but in a composition with other references, it might become a luxurious tangle of supple folds. Regardless, I also admire this painting just as a painting. The internal painting, as well as the transition from drapery to wall, is very sensuous.

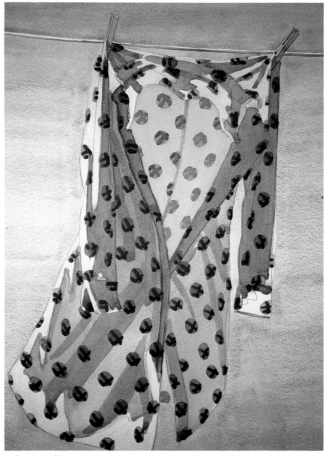

Orlando Pelliccia, UNTITLED, watercolor, 30″ × 22″ (76.2 cm × 55.9 cm)

Orlando Pelliccia uses a simple but exceptional value and color system in this ingenious and humorous painting of a dress on a clothesline. After an initial drawing, the very pale yellow was laid in. When it dried, he planted the red and black decorative medallions throughout the entire dress. Then came the gray of the deep shadows and, finally, the intense yellow areas that are backlit by the sun. At Dino's hand, the cloth is imbued with light, driven from its inanimate banality into the persona of a lively, dancing specter.

DAY 6
Focus

A viewer looks at your painting. She sees what she wants to see. Her gaze finds the parts that she enjoys, that are meaningful to her, maybe to her alone. But there is also something in your painting, small but significant, that distracts her reverie and gently forces her to look at the painting, however briefly, as *you* would wish her to look at it. This is a focus, or focal point, or point of emphasis—yet another potent compositional tool.

As you will see, focuses can be easily varied and as clever and inventive as you can possibly make them. They can be intense or subtle. Focuses enhance space. There can be one focus or many. One focal point can establish a biased stance from which the rest of the painting is viewed. More than one focus can move the eye from point to point. Most focuses are made by contrast—one thing stands out in a field of things of another kind. Another way of focusing attention is by isolation—one thing on one side of the field, everything else on the other side. Or there can be a focus on an element of a story depicted in a painting—a letter suspended in space, falling from the hand of a drowsy girl.

Color. A spot of one hue alone among many colors, or a contrasting temperature, or an intense hue among grays, or vice versa, will draw attention to itself.

Value. A dark spot among middle and light values, or a light among middles and darks, or a middle among darks and lights, attracts the eye.

Scale. Usually a small shape among larger shapes is the focal point, but you could evoke a more obvious focus with a large shape among small ones.

Shape. A geometric shape among irregular forms, or vice versa, draws the eye, as does a square among circles, a triangle among rectangles, or any shape that is noticeably different from those that surround it.

Technique. Isolate any one technique in the field of another; a wet-in-wet shape, for example, in a field of drier, more defined marks. The possibilities here are staggering.

Narration. This may be a "realistically" painted form among distorted natural forms or, as mentioned above, a situation or drama, i.e., a letter falling from a girl's hand.

Exercise: Establishing a Focus. To investigate the effect of focus, choose a cluttered interior space. Before you begin to paint, decide on what kind of focus you wish to use. You can combine many, even all, of the elements listed to produce one point of emphasis. Should you choose to paint more than one focal point, be careful not to diminish the drama. I suggest you establish a hierarchy with one dominant focus and several subordinate ones. Keep the focus clear, even exaggerated, so that you can see the full effect of this demarcation. And in every painting that you make, always consider if, what, and where focal points will be used.

Focus on color. In zone 1, the red shape is the only color not repeated. In zone 2, the orange shape is the only warm shape in a field of cool. In zone 3, purple is alone in crowd of grays. In zone 4, a brownish gray sits amidst a group of more intense colors.

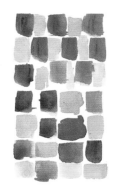

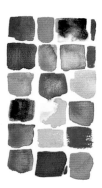

1 2 3 4

Focus on value. There are two focuses in this example—the dark red splotch and the pure white shape, both in a pool of middle value.

Focus on scale. All of these similar shapes are roughly the same size, with the exception of the very small one at center right. It is the focal point.

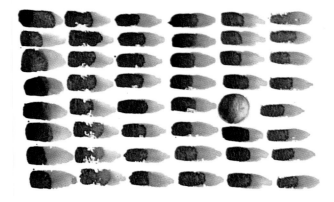

Focus on shape. It's not hard to find the focal point in this field of bullet-shaped lozenges. Do I even need to point it out?

Focus on technique. All of the constituents of this simple grid are painted with irregular water spotting except for the flat rectangle in the second row, third from the left.

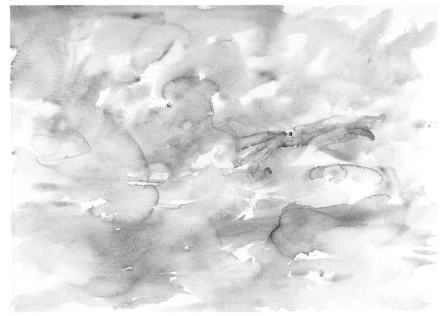

This painting illustrates the final type of focus I discussed, focus on narration. In a field of very wet, breezy marks, a squid emerges as the primary focal point, complete with beady little black eye. My intention in this painting was to make a very vague space in which the gentle creature could swim—or fly, for I made the reference to sky stronger than that to water. The viewer assumes the squid swims in water, but his eyes whisper sky. This is just the quiet tension I sought. Everything else was intended to elicit peace and contentment.

Michael Crespo, SEASCAPE, watercolor, 22" × 30" (55.9 cm × 76.2 cm)

Madeline Terrell, student work, 15" × 10" (38.1 cm × 25.4 cm)

Madeline Terrell provides a fine example (right) of a color focus that reinforces a narrative focus. There is definitely a red spot in the center of these blues and greens and grays, but there is also a living, clucking rooster attached to that red. We cross a broad, vague abstraction to get to his well-defined head; a surrounding warm green emphasizes its redness. This fellow rules this roost and I find his position in the space so uncanny, I'm not going to even mention any other focuses. I'll just let you muse over them alone.

Madeline Terrell, student work, 9" × 16" (22.9 cm × 40.6 cm)

I don't think that there is much doubt about the primary focal point in Jack Knopp's misty, damp painting of a typical rural Louisiana home. The red chimney glows amid muffled grays. It is supported as a focus by the explosive tree shape that surrounds it. Obviously there are a lot of other events that attract the eye—the green door for one—but there's no denying the force of the red beacon. This is a lovely painting, filled with energetic strokes and deftly orchestrated wet colors.

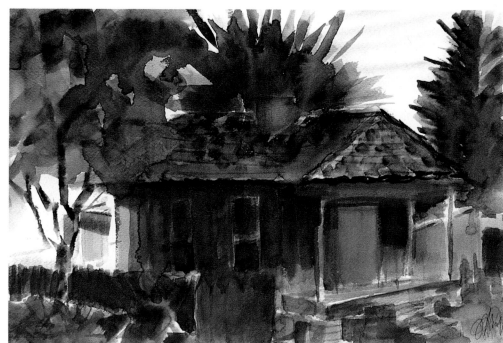

Jack Knopp, CABIN, watercolor, 12" × 18" (30.5 cm × 45.7 cm)

Madeline Terrell gives us levels of focuses to ponder in this painting (left) of a corner in her house. The air plant is highlighted with blistering opaque yellow-whites. I think we can agree that these form the primary focus, and they are conveniently located dead center. We relate them to the vertical of light on the left side, in the doorway, which illuminates them. This is a secondary focus, as is the blue of the furniture and the blue of the pot in the lower left, vibrant colors in a gray field. Madeline enjoys a great command of the medium, providing us with puddles of delight throughout the composition.

DAY 6: Focus

Joe Holmes struggled a little with perspective to give us this view through his apartment. He has drenched the space with a harsh incandescent yellow light; all the shadows are gray. His intended focuses are clear. I zoom first to the small red box on the table: not only is it an intense red object in a field of yellow, it's a *tiny* red object in a large room. The obvious big blue window catches my eye next; there is another focus in the strong yellow of the overhead light. Note that Joe has chosen the three primary colors for his focuses. When there is more than one focus, our attention tends to move around from one to the other. This is an obvious benefit of having more than one, but a certain scale and drama are sometimes lost because of it.

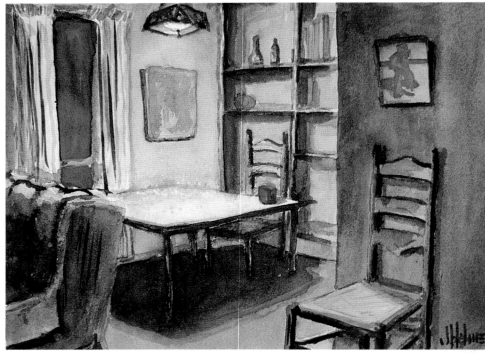

Joe Holmes, student work, 8" × 11½" (20.3 cm × 29.2 cm)

Christy Brandenburg also uses the primary colors as focuses in this articulate rendering of her apartment in Florida during spring break. At the immediate left of the table, yellow moves to blue, blue moves to pink. For me, the primary focus is a toss-up between the shirt and the yellow and blue. The shirt is a prime candidate because it's an isolated color in the painting. There's only a faint glimpse of it elsewhere—in the mirror to the right. The empty shirt also acts as a surrogate figure as it stands there behind the table.

The interaction of the intense yellow and deep blue is also a strong focal point, but it's diffused a bit by the other yellows and blues on the table. Actually, the pink shirt and all of the yellow and blues cluster to form one massive focal point. The suitcase at the far left becomes another focus, by virtue of its isolation from the other strongly defined objects. Everything else is muted. They're all focal points, all interacting; the viewer determines their hierarchy.

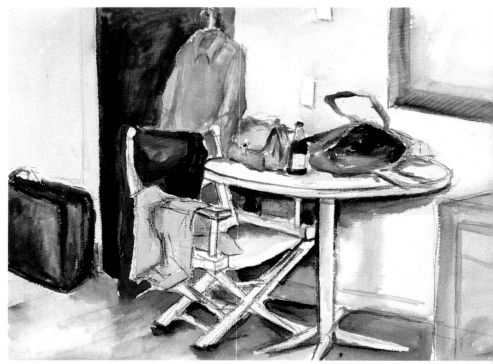

Christy Brandenburg, student work, 10" × 14" (25.4 cm × 35.6 cm)

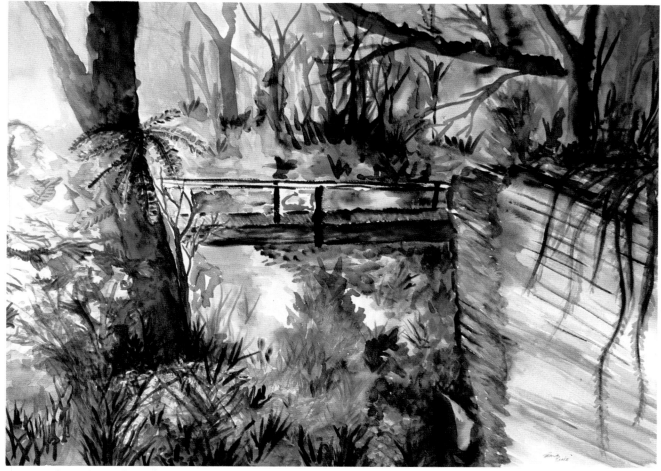

Patricia Burke, student work, 22" × 30" (55.4 cm × 76.2 cm)

Romi Maegli, student work, 5" × 8" (12.7 cm × 20.3 cm)

Patricia Burke has painted a landscape with a remarkable diversity of brush-strokes. She seems to describe every square inch with a different kind of gesture. The painting is alive with different brush movements. Not only does she describe a space, she also expresses it. The painting is unified by its dominant palette of cool blues augmented with occasional splashes of warm gray. But deep in this swampy space is a screaming red-orange focal point, beautifully executed as a focus but baffling as an element of the narrative.

In this flurry of agitated, irregular marks, Romi Maegli reveals a dark triangular monolith deep in the space. The eye is drawn to it not so much by its dark value as by its solidity in the rain of purple, blue, and red chaos that obscures its edges with flurries of dynamic dripped paint—an excellent example of focus on a contrasting shape.

49

DAY 7
Aerial Perspective

When I first mention aerial perspective to my students, many of them assume that it has something to do with drawing the landscape from an airplane. It certainly sounds like an exciting idea, but as a painting term, aerial is defined as "of the air," that is, perspective of the air, or atmospheric perspective—a system that produces a logical two-dimensional depiction of three-dimensional space.

As we gaze across a landscape, especially over an unobstructed deep view, distant forms seem hazy, muted, indistinct—much less certain than the things at our feet. This is caused by distance, light, weather, and the inefficiency of our eyes. Although it does not always occur naturally, this is the basis of aerial perspective, which we produce by combining our knowledge that the clarity of forms diminishes as they recede into the distance with certain elements of our *craft*: color, focus, and value.

Exercise: Aerial Perspective. Choose a location in the landscape where some deep space is visible. If you're fortunate, you may happen on a day when the natural phenomenon is clearly evident. It doesn't really matter, however, for once again we are going beyond vision and applying a painting concept.

In your painting, modulate the color from very intense in the foreground to gray in the background. The edges of the forms should be hard and focused in the foreground, soft and watery in the background. Wet-in-wet technique would serve well for the background; for the foreground, allow layers of color to dry before overpainting. Some lines drawn in the foreground can also strengthen the focus. Strong value contrasts move forward, so use strong darks and lights in the foreground and a very close, limited range in the background. The depth of space will be directly related to how drastically you modulate all these elements.

Exercise: Reverse Aerial Perspective. To glimpse the other side of this system, make another painting in which you reverse all that you did with the elements of the first exercise. Intense colors, contrasting values, and hard edges will now appear in the background, while gray colors, close values, and

blurred edges huddle unfocused in the foreground. Although this painting may not look as natural, the depth of the space will still be intact. In future paintings, you may wish to introduce more spatial irony by juggling the different elements. For example, focus and value may still diminish from front to back, but color intensity could be reversed. Regardless, atmosphere is a very vital element of our paintings. Keep it in some kind of perspective.

Here, the foreground colors are the most intense; as they move back in space, they gradually become grayer. The farthest color is almost neutral.

Here, active shapes and lines are sharply defined because they were painted on dry paper. The background was laid on wet paper and thus is very nebulous.

In this example, strong value contrasts in the foreground gradually diminish to faint differences in the background.

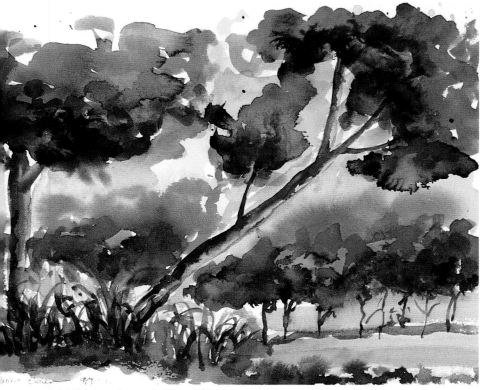

In this energetic landscape, John Eblen uses the entire surface for his foreground. He applied the rules faithfully, painting the nearest trees and scrub grass with heightened color, value, and focus. Although he doesn't make any great changes of color through the painting, the greens do diminish, eventually becoming gray back along the horizon. Although there is some visual interest in the background, it doesn't compare to the dramatic tree trunk that spans the center of the composition.

Everything in this system is relative. If you have gray color in the foreground, you have to have even grayer color behind it. You don't have to follow the system rigidly, though. Don't worry if your gradations fall off a bit. It's the overall effect that counts.

John Eblen, student work, 11" × 15" (27.9 cm × 38.1 cm)

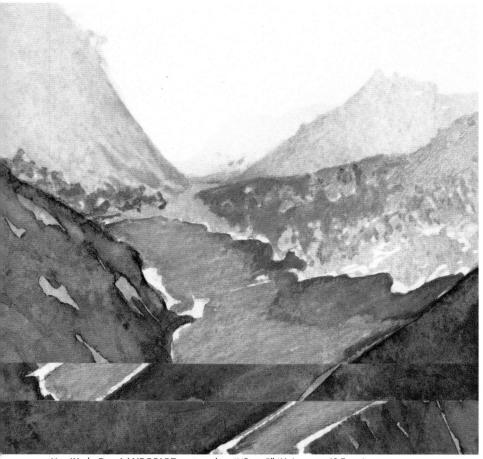

Van Wade-Day uses the last three mountains in this little painting, one at the top left and two at the top right, to mark a sudden plunge deep into the space. Until that disjunction, colors are more saturated, value differences are crisper, and edges are more certain. All of this degenerates into wonderfully faint plains dragging us miles into the terrain. Another emphasis in the foreground is the horizontal band that shifts the entire natural space over to the left. This insert widens the gap between the foreground and the waning mountain in the distance.

Van Wade-Day, LANDSCAPE, watercolor, 4½" × 5" (11.4 cm × 12.7 cm)

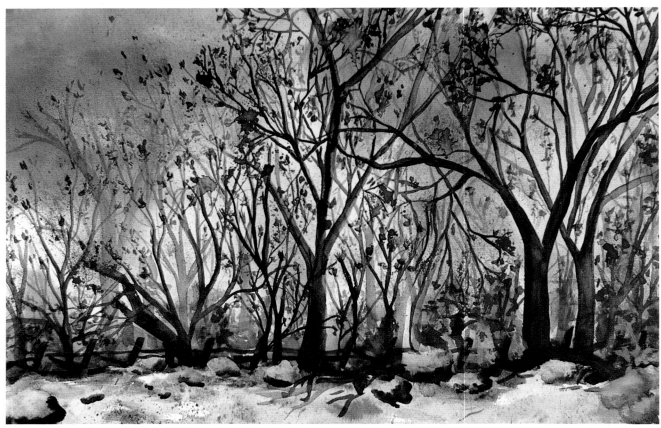

Patricia Burke, student work, 15″ × 22″ (38.1 cm × 55.9 cm)

Patricia Burke's fine late-evening woodland scene is ablaze not only with dramatic temperature contrasts, but also with the crackling web of tree shapes. And these tree shapes are the major vehicle for aerial perspective. We peek through the legible trees of the foreground and find a sequence of others that grow paler and less defined as they recede. She has further emphasized the foreground with high-contrast rocks and a shower of splattered paint. But trapped in this well-articulated aerial perspective is a band of fiery warm hues that contradicts the logical space.

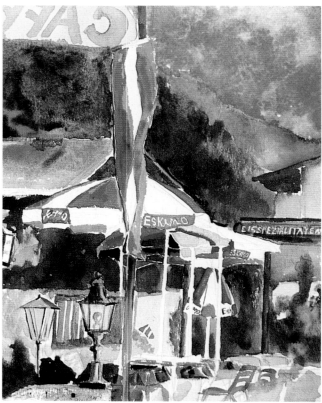

Alice Verberne painted this scene while sitting in a mountain-side cafe on a recent European holiday. That alone is enough to arouse my interest, but the painting is also a fine example of the relativity in aerial perspective that I spoke of earlier. The color in the distance is not gray, but compared to the pure cadmium red of the foreground it might as well be. Alice has exploited the strength of the primaries and paper-white, jamming the foreground into the viewer's face. In the background she used a wet-in-wet technique to soften the edges, nudging the forms farther away from the highly focused foreground. Speaking of focus, there is actually a faithfully rendered lightbulb here.

Alice Verberne, student work, 10″ × 8″ (20.3 cm × 25.4 cm)

52

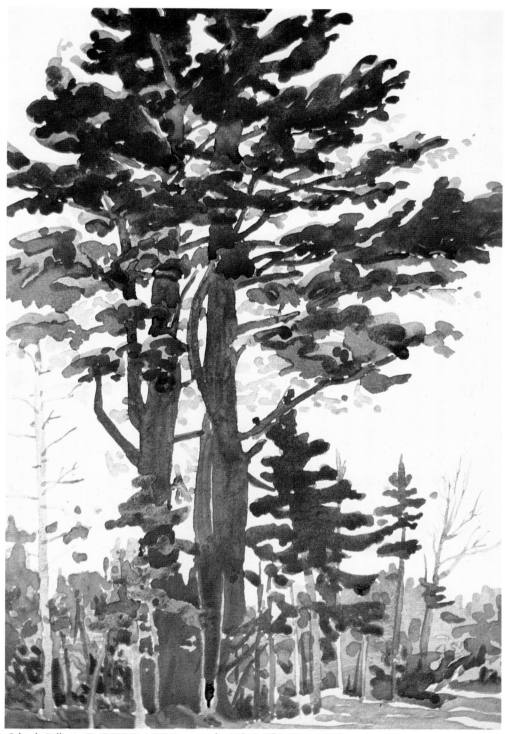

Orlando Pelliccia, PINE TREES, MAINE, watercolor, 22" × 15" (55.9 cm × 38.1 cm)

Orlando Pelliccia exploits aerial and linear perspective in this light-drenched portrait of two large pines. Although the color in the painting is quite gray, the foreground is set off by a comparatively intense yellow-green, strong value contrasts, and sharp linear and edge focus. As the eye moves in on the descending treetops, all of these elements diminish to a faint wash of gray.

This painting is constructed from the background to the foreground, as are most watercolors. This is a very accommodating system for aerial perspective. Color, focus, and value can be easily graduated in successive layers of paint.

DAY 7: Aerial Perspective

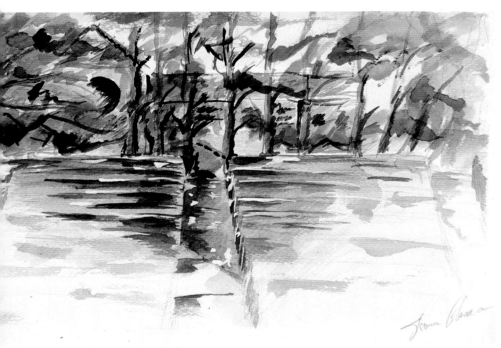

In this painting from the stage of an amphitheater, Shaun Aleman reverses the rules of aerial perspective but still constructs a very effective and decidedly tense space. Unfocused strokes of gray gain strength as the space moves up and away to the background, where harsh primary colors, cutting values, and strong linear accents inhabit the most distant zone.

Shaun Aleman, student work, 10″ × 17″ (25.4 cm × 43.2 cm)

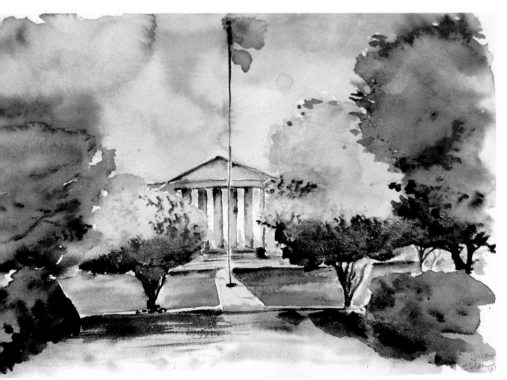

John Eblen has also reversed the system, although not as drastically as Shaun Aleman did. The focus moves from watery trees and shrubs in the foreground to slightly more definition in the middle ground to the more pronounced resolution of the building in the background. Color changes from grayed blue-greens to yellow-greens to dull red in the flag to a rather intense spot of orange on the building. Accordingly, the light intensifies, as if it were changing from a shadowed area in the foreground to a dramatic spotlight on the building. John proves that with subtle and even gradation, space can be just as seductive when the principles of atmospheric perspective are reversed.

John Eblen, student work, 11″ × 15″ (27.9 cm × 38.1 cm)

Stanley Sporny, U.N. HEADS, watercolor, 12" × 26" (30.5 cm × 66.0 cm)

Stanley Sporny is a gifted painter whom I met when he was a visiting artist here at Louisiana State University. He lives in Sri Lanka, and his paintings reflect his world travels. In this painting of a New York City street, he uses classic aerial perspective to push us to the end of the tunnel-like avenue. The foreground is rich and vibrant, with two heads sitting like sentinels on either side, guarding the threshold of the deep space. Color, value, and focus fade progressively as the eye moves along the lines of perspective to the far background.

My wife, Libby, paints a more abbreviated, but equally impressive, version of aerial perspective. The entire surface of the painting is flooded with the foreground information of boy and leaves. They are painted with intense colors, extreme lights and darks, and sharp, detailed focus. Behind them, at the bottom of the painting, the space moves quickly to a paler middle ground with a slightly distinguished evergreen, and then to the deep background, a vague tree line of icy blue. There are no subtle transitions here. The aerial perspective is abrupt and dynamic.

Libby Johnson Crespo, BOY IN FRONT OF A BANANA TREE, watercolor, 9" × 6" (22.9 cm × 15.2 cm)

DAY 8
Color Expression

Of all the elements that define painting, color is by far the most complex, abstract, spiritual, and forceful. The colors that we paint most often, the ones we wear, the colors in our dwellings, the ones we cherish most, those that identify us like fingerprints, are apt to change many times as our experience accumulates. This exercise will help you determine which colors make up your personal banner right now.

Exercise: Color Expression. With your full palette of color at hand and a sheet of paper no smaller than 5″ × 12″ before you, load your brush with a color that you like very much or that reflects your mood. It may be straight from the tube or a mixture. Brush the color on the left side of the paper, making a swatch about one inch wide by three inches high. Study it for a while, then choose another color that you like and that harmonizes with it. Paint a swatch of that next to the first. Continue to put colors down until you have ten, all of which you like, all of which you feel harmonize with one another. They do not all have to be completely different hues; they may be any colors you wish.

Repeat this exercise often in the months to come, each time painting the colors you like or want to see at that precise moment. Stagger the time lapses between the exercises—weeks between some; days, even hours, between others. After you have completed eight or so, study them to find any similarities regarding hue, value, intensity, or temperature. These similarities may point out your particular color impulses and will help you use color as a tool for personal expression.

Color Theory. In the previous exercise, I directed you to paint colors that harmonize, harmony implying friendly colors chosen by intuition. Color theory does supply us with four basic harmony schemes. The most elementary is monochromatic harmony; one hue moved through a value range is, if anything, harmonious. Analogous harmony is achieved by using colors that are adjacent on the color wheel, such as red-orange/red/red-violet or green/blue-green/blue. We get complementary harmony by painting with colors that are opposite each other on the color wheel. Blue and orange together produce a dazzling color scheme, as do red and green, or blue-violet and yellow-orange. Finally, there is the triadic harmony of colors that are evenly spaced on the color wheel, such as the primary red/yellow/blue triad and the secondary orange/violet/green triad.

When there is no harmony, there is discord, and color discord occurs when colors are visually disquieting because they seem to share no intimacies with one another. Like harmony, discord tends to be somewhat subjective—my harmonies could well be your discords—but most often the culprit is the use of colors that are widely separated on the color wheel (ruling out the complements, of course). The discord is especially distasteful when there are no value contrasts between the colors. Strong, dramatic value contrasts can make disharmony palatable. My favorite discordant pair is red and blue-purple. I'm not necessarily presenting you with an evil. Someday you may find it necessary to make your point by irritating, rather than soothing, your viewer's eye.

As painters, we tend to stray from theoretical color formulas and work from intuition, or perception, or need. But a theory can provide us with a place to start, a platform from which to seek freedom and expression, or even a concept to disprove.

Exercise: Arbitrary Color. Keeping in mind some of today's theory, go out and find a composition in the landscape and paint by observation everything except the color, which should be arbitrary. Invent the color; don't paint what you see. You may work in harmonies, discords, colors you like, or colors you dislike. Just be sure that they have nothing whatsoever to do with the landscape you are observing. You'll discover while painting that this problem forces you to be more aware of how values and forms are constructed once they are separated from their colors.

Here, a bottle of ink is painted solely in Payne's gray. It is always easiest to work with one color, provided you make a strong value statement. Aside from the intrinsic qualities of the hue itself, drawing and manipulation of values are your only tools. Make those paper-whites sizzle for you.

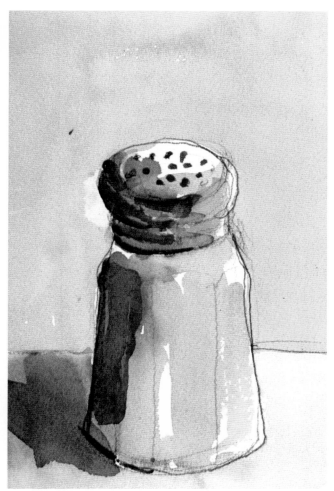

This was my favorite. I used the complements violet and yellow because together they just reek of light. I tried not to let the complementary gray appear; I wanted the full force of their marriage.

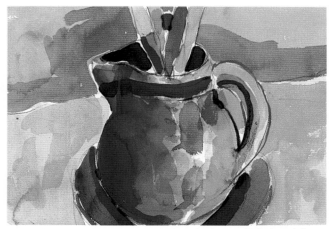

This bottle, containing a liquid watercolor that I never tried, served as my model for an example of analogous harmony. I used green/blue-green/blue as my color scheme. These colors just melt together. It's very difficult to muddy them.

Naturally, I used the primary triad to depict my little brush jug. Nothing equals the power of the primary triad, although sometimes it is a little difficult to model objects with it. I had my troubles with this one, but in the end the harmony will usually disguise any faux pas.

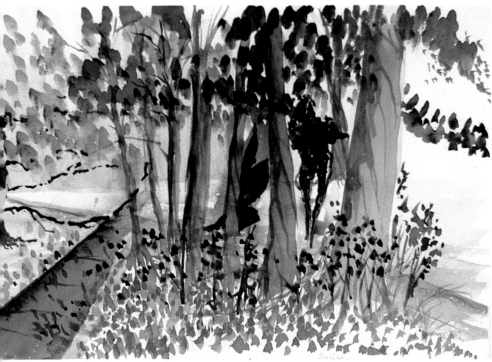

In a painting distinguished by invigorating brushwork, Salim Hassan has used the primary triad as a general color motif. He does introduce quite a bit of the secondary orange, and just a stroke of green, in the tree trunks. As he was painting, he informed me that it was very difficult for him to work with arbitrary color. Discarding personal preferences and searching for the new is difficult, but that's what I'm always asking you to do. I think it's essential in the painting process. When painting, I always try to assume that I'm not quite sure of who I am and that I absolutely don't know what I like. This doesn't last very long, but it does coax me to peek outside my tunnel once in a while and look at things a little differently. In the end, Salim admitted that the exercise was worthwhile. He didn't like his painting that much, but I did.

Mohd. Salim Hassan, student work, 11″ × 15″ (27.9 cm × 38.1 cm)

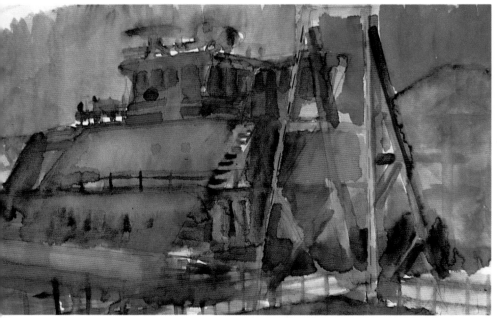

Jack Knopp exhibits his wonderfully fluid technique with a palette of analogous colors capped on either end with the complements blue and orange. He has run through all the possibilities between them: orange, red-orange, red, red-violet, violet, blue-violet, blue. It is a rich and heavy scheme that he manipulates to give us somber, shadowy, almost nocturnal areas and bright, dazzling light coexisting in almost perfect accord. I spoke of his fine technique; I really believe it is more than good wet-in-wet control—it is a brazen self-assurance that the marks will work if you just believe in them.

Jack Knopp, UNTITLED, watercolor, 12″ × 18″ (30.5 cm × 45.7 cm)

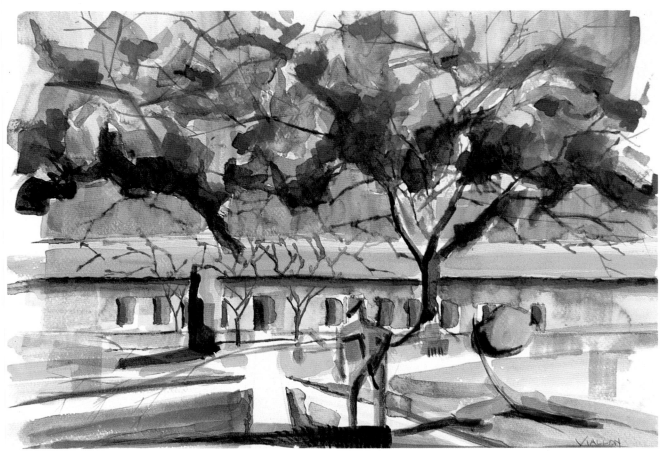

Robin Viallon, student work, 15″ × 20″ (38.1 cm × 50.8 cm)

Dierdre Broussard, student work, 12″ × 9″ (30.5 cm × 22.9 cm)

Robin Viallon magnifies the intensity of the complements blue and orange with an equally hard-hitting value range. He accents the strategy with smaller doses of the other complements green and red and yellow and violet. Basically it's a complementary harmony that uses all of the primaries and secondaries. Should you attempt such a system, be sure to let one pair dominate. The web of spindly lines drawn in the rocklike clumps of the trees is a fitting and effective counterpoint. That man posed so jauntily in the space is actually a sculpture; we spent the day painting in the sculpture department's courtyard.

Here is another view of a figurative sculpture in the landscape. Dierdre Broussard has used two pairs of complements, blue and orange and yellow and violet. I feel the color here has more to do with discord than with harmony: The analogous yellow and orange play havoc on the analogous blue and violet. Dierdre has also introduced a rather sickly green sky to disturb the space even more. I'm not attacking Dierdre—she is a fine painter who has made good use of discord to transform the campus landscape into a ravaged wasteland, complete with nightmarish soldier.

59

DAY 8: Color Expression

Christy Brandenburg, student work, 21" × 31" (53.3 cm × 78.7 cm)

Christy Brandenburg evokes the harmonics of the primary colors at their best in this buzzing abstraction. She never would divulge the source of her painting, not that it matters. The little streamers of red that fly around the big blue and white structure like insects are wondrously imaginative, as are the highly unpredictable brushmarks. The yellow background surrounds the red and blue and white with a radiant light. Notice the white linear grid that plays hide-and-seek along the top of the painting. Christy made me promise to mention it. It's her favorite thing in the painting.

Maureen Barnes, student work, 12" × 9" (30.5 cm × 22.5 cm)

Maureen Barnes paints the humanoid sculpture in friendlier colors and with a jaunty brush. Maureen attempted to paint the complement of each color she observed. Thus the blue-green bush became red-orange; the orange dead magnolia leaves on the ground became blue. She kept the painting sparse and direct, and its energy stems from that. Incidentally, all the sculptures depicted in these paintings were made by a very talented sculptor, Mark Tomecek.

Patricia Burke literally flings this painting into existence. The harmony is based on the primary triad, with blue dominating. The color is bound to the dynamic texture and is forced to share the limelight. Note the beautiful effects, visible in the bottom right quadrant, of dropping opaque white into the wet color.

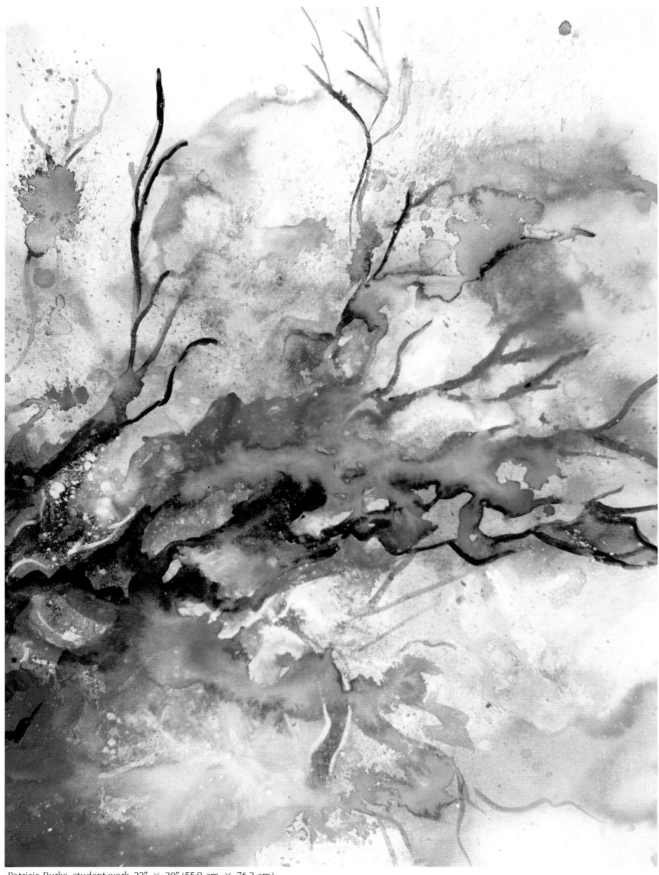

Patricia Burke, student work, 22″ × 30″ (55.9 cm × 76.2 cm)

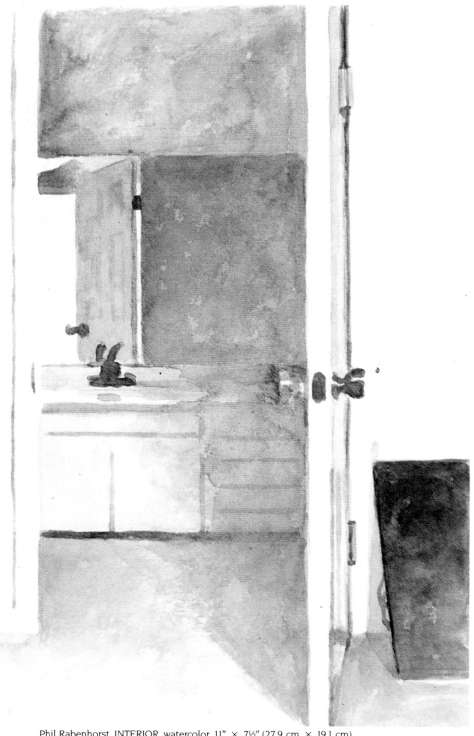

Phil Rabenhorst finds the quiet murmurings of monochromatic harmony perfectly suited to his splendidly designed interior space. He used an array of greens, both warm and cool, in a very personal, "almost dry" damp technique. The open door confronts us in exaggerated perspective. To the right of the white vertical door edge is crisp, organized geometry; to the left is a slab of misty atmosphere pointing us into the adjoining room. It is a well-designed event in a silent, enigmatic painting.

Phil Rabenhorst, INTERIOR, watercolor, 11" × 7½" (27.9 cm × 19.1 cm)

Steve Erickson's arbitrary color shrouds an old Louisiana home with an eerie, exaggerated light that evokes the tales of ghosts that usually accompany such places. It's also the kind of light that might occur in the silence that looms before a major storm. Steve deadened the dominant yellow and violet and used their gray as a transition. He used equally subdued reds and greens as secondary colors. All these repressed colors flood a well-conceived value range and fine, literate drawing.

Steve Erickson, student work, 21″ × 15″ (53.3 cm × 38.1 cm)

DAY 9
Multiple Tactics

Another innovation in twentieth-century art is the practice of making space by combining a number of different techniques within a single painting. You have learned that you can evoke a sense of space with contrasting two-dimensional elements because opposites usually separate rather than attract, forming different levels of illusionistic space. For example, darker values may appear to be relatively distant in the space of a painting, while lighter values appear closer to the viewer. The same principle applies to contrasting techniques. It's easy to imagine the space implied by planting a flat-painted shape in the middle of a billowing wet field.

Exercise: Varying Tactics. Today, we will go well beyond such simple abstraction by applying the very liberating practice of multitechnique painting to the logical, continuous space of a still life—objects related by perspective and scale but tugged apart and relocated by contradicting techniques. We have made limited use of this tactic in previous paintings, employing two or three maneuvers within a single work. Now we will move to extremes, however, rendering unique each form and facet of the space.

Let's review some possible techniques that could be applied.

- More or less conventional rendering, light to dark, loaded brush with dry paper, not much brushstroke indicated, painted directly or with layered transparencies
- Very realistic rendering (known as trompe l'oeil or trick-the-eye painting)
- Any of the various brush techniques: stampings, strokes, or compound strokes, wet or dry, made with either tip or heel of the brush
- Any of the wet-in-wet techniques
- Any of the four washes: flat, graded, wet-in-wet, or irregular
- Any of the myriad of textures: lifting out with tissues, paper towels, or napkins; stamping with objects; applying paint with squeegees or palette knives; splattering with a toothbrush; dripping paint, causing blooms and water spots; using masking solutions, crayon resists, or salt lifts; wirebrushing or sandpapering the paper first
- Pointillism: creating the illusion of volume and light by building a form with hundreds of dots of different colors and values
- Multiplanar, or multiple-point-of-view distortions
- Opaque gouache technique
- Edge variations
- Collage: gluing other materials to the painting—fabrics, photos, cut-up fragments of discarded watercolors, newspapers, magazines, or whatever may be at hand

Of course, you may have developed other techniques in your painterly wanderings. Anything goes in this painting. Work from a still life with a number of objects. Use different techniques to paint each object and the background space. The more objects, the more techniques, the more excitement. You might consider making a plan for each component before you start painting, or you might work intuitively from object to object. Remember that variations in color and value can also push the different areas farther apart or draw them together.

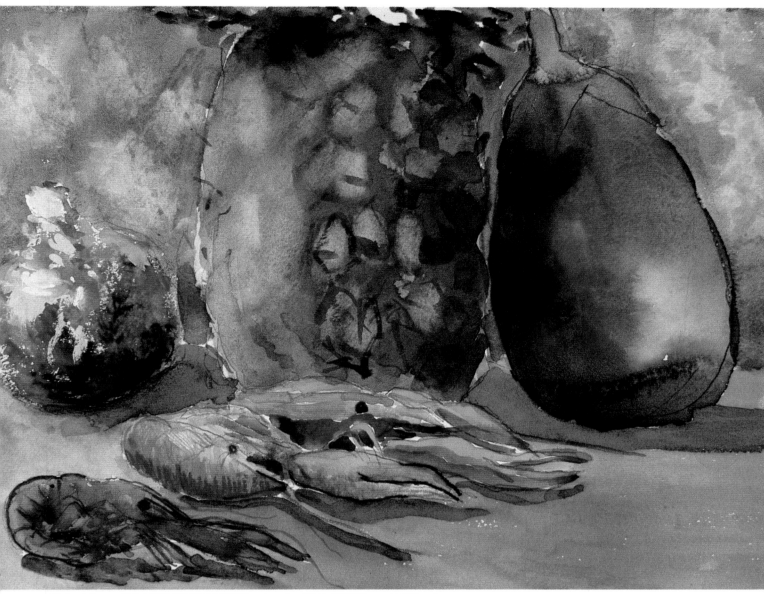

Michael Crespo, STILL LIFE WITH CRAWFISH, watercolor, 11" × 15" (27.9 cm × 38.1 cm)

In planning for this painting, I decided that I would plot techniques for the two largest shapes, the pineapple and the eggplant. The others would be painted one by one so I could be open to happy accidents and surprises. I painted the eggplant wet-in-wet very quickly and moved on to the pineapple, on which I layered some yellows and greens. When they dried, I used my nylon bristle brush and some clean water to scrub out the lights; to insinuate a little texture, I flicked in some strokes of dull red. The closest crawfish was painted indirectly, first rendered in shades of gray and then overpainted with a transparent red-orange. The next was drawn with watercolor pencils and washed over with clean water. The third was constructed with hard-edged horizontal planes. I decided the onion should pull away from the pack, so I built it up with nervous drybrush marks and noted the light with gouache. At this point I felt some unification was needed, though I could easily have decided to pursue the opposite strategy and dissociate the parts even further. The eggplant and pineapple were both soft and glowing, and I tried for the same feeling in the background, lifting some vague lights out of a wet wash with tissue. I finished off the ground plane with a flat, undistinguished blue. Relationships founded with varying techniques can be just as significant as the oppositions in molding the space.

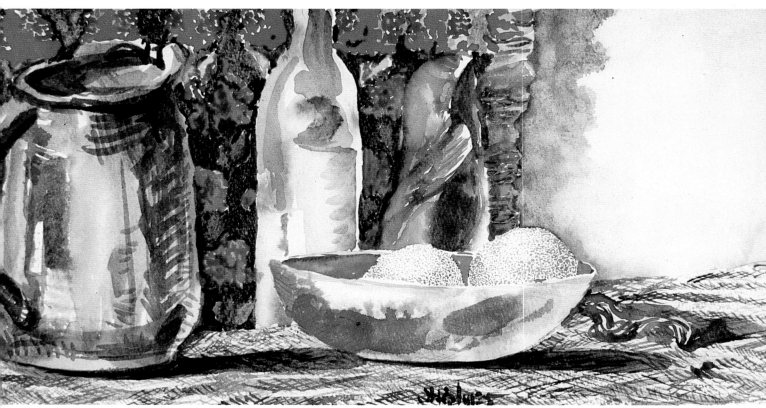

Joe Holmes, student work, 8½" × 17" (21.6 cm × 43.2 cm)

Joe Holmes approached his painting in a random fashion, and in the end he uncovered a striking structural dimension. There is a lot of contrast between the large strokes that describe the objects and the fanatically decorated environment. The oranges in the bowl are the exception; their pointillist construction links them to the background and ground plane. The latter is made of layers of multicolored cross-hatchings, while the busy decorative hanging drape is accented with gouache. The other objects and the square patch of light on the right are painted in various more traditional techniques. Joe never really ventures from the brush, but he varies its handling considerably.

Note the crisscrossing of space as our eyes are directed diagonally across the painting, following the bland techniques of the objects to the light source on the right, while the more intensely decorated areas imply a counter diagonal movement from bottom right across the oranges to the background drape.

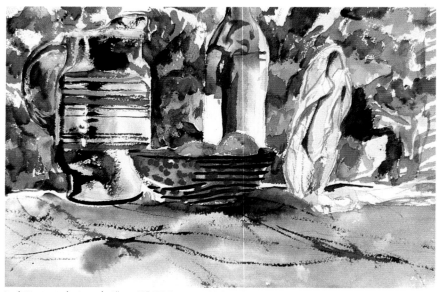

Joel West, student work, 8" × 12" (20.3 cm × 30.5 cm)

Dynamic fractured light dominates this painting by Joel West. The colors and values of the slipper, wine bottle, and pitcher are carried over from the background, but they have gained their independence through the contrasts in technique. The oranges in the blue bowl are a powerful focus in the field of red and green and the grays they produce. Joel changed tempo dramatically in the foreground with an undulating wet-in-wet ground plane mysteriously, but successfully, overpainted with dry graffiti that brings to mind chalk squeaking across a blackboard.

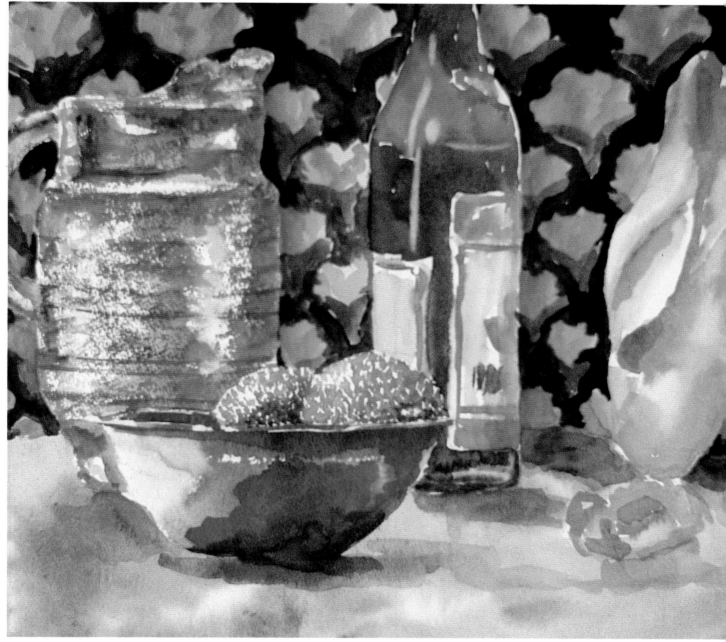

Madeline Terrell, student work, 14″ × 15″ (35.6 cm × 38.1 cm)

The warm orange and yellow hues help pull Madeline Terrell's painting together, making a tepid field in which to plant the single blue focus. Her changes of technique make for good push and pull around the composition, and for some reason my eyes are engaged in a constant tugging back and forth between the drybrushed pitcher on the left and the soft wet-in-wet ballet slipper on the right.

Robin Viallon, student work, 12" × 16" (30.5 cm × 40.6 cm)

Robin Viallon sets this menagerie of objects and shapes into whirlwind motion with a barrage of both subtle and drastically different tactics. This painting succeeds because of the "torn apart" feeling brought on by the constantly changing surface. For example, examine the juxtaposition of the tangerine, which is heavily developed with layers of orange washes, and the little vase, which is constructed with flat dark blue shapes and a bunch of scribbles—not to mention the gouache flower pattern between or the darting gestures to the right. It would be a formidable task to describe every maneuver. Just let your eyes fly around in this one for a while.

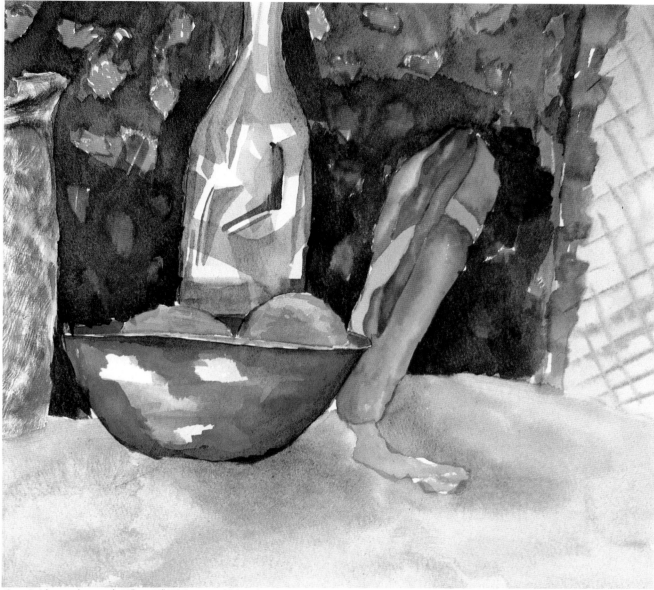

Scot Guidry, student work, 13″ × 14″ (33.0 cm × 35.6 cm)

Scot Guidry establishes a bull's-eye focus by keeping the colors bright, the value contrasts sharp, and the brushwork agitated around the center of this painting. The group of objects is dominated by the fragmented planar surface of the bottle, which looks like a shattered mirror. Wet, relaxed techniques frame this area. Scot also creates a slight tension by deliberately setting everything off the vertical.

DAY 10
Surface Unity

Learning about painting often means painting the extremes of a particular concept in order to better understand its core. Yesterday, you created space by using a different technique for each object and zone in the painting. There were little conflicts at every boundary in the painting that caused the eye to bounce around space from object to object, moved about by their different constructions. The other extreme would be to use one technique for all the components of the subject matter. You may have come close in previous paintings, but I doubt that you have ever maintained *one* technique throughout. By now you're used to letting your tactics change somewhat as you move from form to form, but today I ask that you be rigorous in maintaining one particular manner of working throughout. This painting should evoke slower, more flowing transitions from object to object to background, the continuity drawing the parts together into a whole. Space will be as a single breath, not a storm of many little winds.

Exercise: Using a Single Technique. In a simple environment, organize a still life with three or more objects of different colors. Make a light pencil sketch on your paper and meditate a bit on what particular technique you should use. You may want to go with one in which you are very fluent. I suggest that you decide whether you want a quiet, somber surface, perhaps using smoothly graded value modulations, or the exaggerated activity that rhythmic stroking might indicate. There's little need to review possible techniques; just refer to the list in yesterday's lesson. When you've selected one, proceed to paint, doing your best to develop every nook and cranny of your painting with the same technique.

Since the goal of this problem is to produce a unified surface, you might consider applying one or two flat washes of color across the entire surface of your completed painting, just to strengthen the unity. Choose a color, preferably a nonstaining transparency, that you feel would work well laid over the existing colors in your painting. Consult the chart you made early on. Apply a basic flat wash. If the color doesn't work as well as you might have expected, apply another to modify the first. Do not go beyond two, or you may find yourself in too deep.

Renee Maillet relies on a buildup of splatters to generate this unusual little landscape painting. She began with a vague shape of wet paint to indicate the row of trees, then spattered on more paint by holding a loaded brush just over the surface and tapping it on a finger of the opposite hand. A wide variety of colors was used in the process, but they play second fiddle to the prickly needle shapes of this common stroke that she put to fantastic use.

Renee Maillet, student work, 7″ × 8½″ (17.8 cm × 21.6 cm)

Stella Dobbins, FOREIGN RESONANCE, watercolor, 26" × 40" (66.0 cm × 101.6 cm)

Stella Dobbins pieced together a multitude of tiny flat shapes to make this incredible still life. She began by making a very complete pencil drawing, consolidating all of the intricate fragments into the objects and environs of the still life. Then she colored in the shapes, paying particular attention to value, for it is the ebb and flow of lights and darks that gives credibility to this space, allowing identities to continuously appear and disappear in the vast woven fabric of her consummate technique.

Johanna Glenny, student work, 19″ × 24″ (48.3 cm × 61.0 cm)

Johanna Glenny painted this puddle of a still life by repeating the mark of a single brush. She painted quickly, responding very directly, with no initial drawing. When certain areas got too wet, the strokes dissolved into one another, but her mark prevails even in the very faint regions at the top. Johanna had a very determined compositional structure, concentrating the stronger colors and values in the rough triangular shape. To keep it from being totally isolated, she makes a transition in the lower left corner, where some middle values are clustered. The rest of the space is airy, with occasional stampings of pale color.

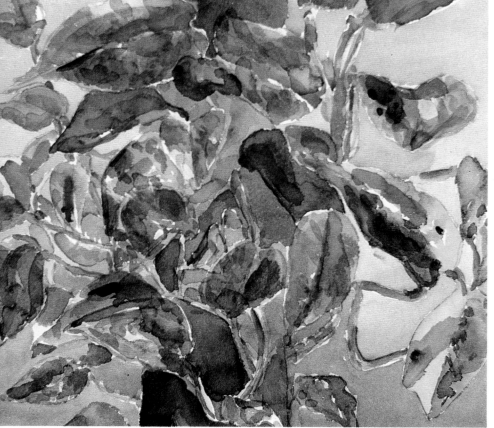

Leslie Wagner, student work, 12″ × 12″ (30.5 cm × 30.5 cm)

Leslie Wagner painted this profusion of ivy leaves with layers of erratic, splotchy marks within well-defined shapes. The obsessive transparent buildup transforms the usually flat leaves into crystalline globules trapping occasional warm bursts of light. Departing from the problem a little, she painted the background flat to better display her handiwork. I applauded the decision and felt there was sufficient unity of technique to maintain the flow of space.

Catalina Stander paints native Louisiana irises with a very deliberate scheme of decorative brushwork. First she painted leaves, stems, and blossoms in flat colors. Then she methodically zigzagged a more opaque color over each, magnifying the stroke over the white background. Her aim was to create a lively but regular movement that linked the entire surface. It is a lesson from the master, Vincent van Gogh, who put brushstrokes to similar use.

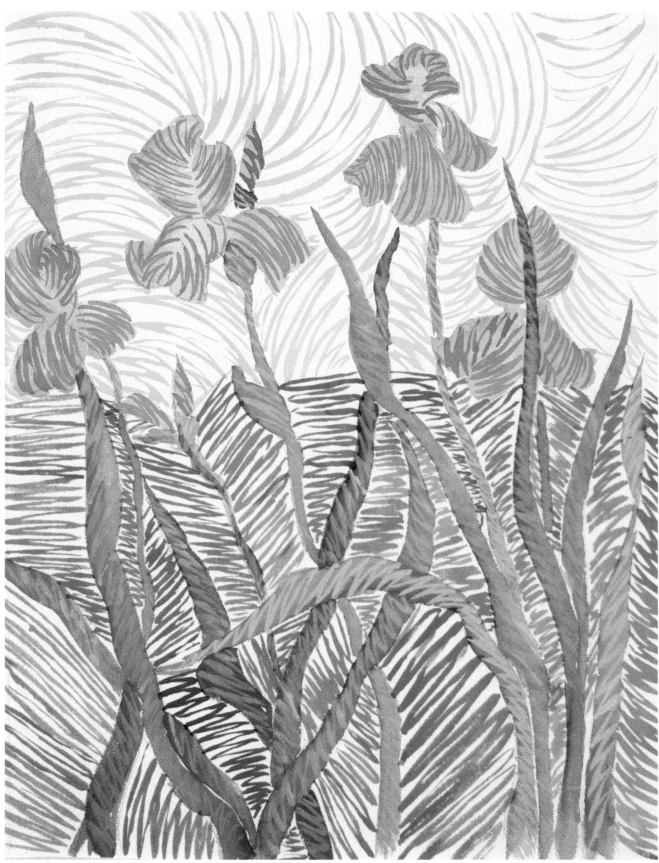

Catalina Stander, student work, 15" × 11" (38.1 cm × 27.9 cm)

DAY 10: Surface Unity

This painting from my ever-expanding fish series is a self-portrait of sorts: The three disjointed figures are personal symbols of my own memory. The technical challenge was to render a vision of my mind. I chose to paint a big, vague, cloudy soup of color—a continuous depth in which to unite the three players. I chose to restrict myself to wet-in-wet techniques, contrasted only with a few lines to clarify forms and the development of the eyes.

I began the painting with the black lines of the fish and wing. When they were dry, I established the soft volumes of the figures by mingling wet colors. I allowed these areas to dry somewhat before I began the sequence of wet-in-wet washes of different colors that drenched the forms. The first wash sullied the still-damp edges. There were at least ten applications of wash, which I alternated in horizontal and vertical passes. These changes of direction are clearly evident in the painting. I allowed some of them to dry before wetting the surface again and painting another; others I worked directly into while they were still wet. When the effect of murky depth was achieved, I let it all dry and defined the eyes, making them sparkle with tiny drops of Chinese white.

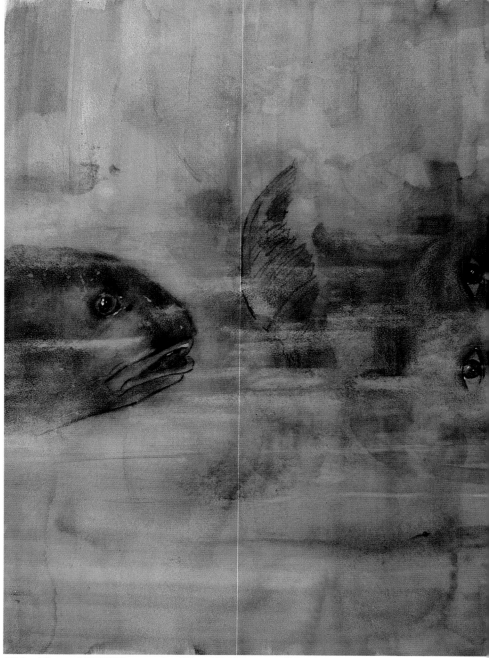

Michael Crespo, MEMOIRS, watercolor, 30" × 22" (76.2 cm × 55.9 cm)

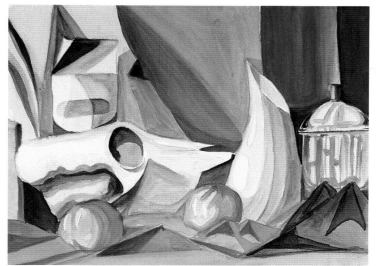

George Chow, student work, 9″ × 12″ (22.9 cm × 30.5 cm)

George Chow uses a very definite planar approach to the many objects that populate this still life. In his initial drawing, he exaggerated surfaces to make them appear to be flat planes, like objects constructed out of scraps of mat board. Then he applied color in a methodical value system, clearly identifying gradations of value. He remained consistent with his difficult technique, even rendering the reflections in the polished coffeepot at right as planes. Despite the many color changes and the excitement of the dancing forms, George's painting remains tightly woven together by the uniformity of his technique.

John Eblen, student work, 11″ × 15″ (27.9 cm × 38.1 cm)

John Eblen used a forceful, jagged stroke to mark the different areas of this active still-life composition. He began by painting the space as a series of flat shapes. Then he worked around the composition, fleshing out the forms with his expressive stroke. The various objects take on drastically different characters as he changes the color, value, and number of his marks. The light-filled glass fishbowl in the center is activated by a conglomeration of faint pastel colors that contrast sharply with the harsh black strokes on the yellow object in front of it. Also compare the bluntly geometric candlestick on the right with the loosely rendered vase next to it. John's boisterous still life is a fine example of a single technique providing unity to the whole without sacrificing the character of the parts.

Amy Holmes, student work, 11″ × 14″ (27.9 cm × 35.6 cm)

Amy Holmes pieced together wet shapes to form this exuberant abstraction from the still life. In practically all of the shapes, she lifted out color with a dry brush and a tissue, leaving concentrated residues of pigments along their borders. This repetition of technique makes the shapes appear to bulge softly from the surface of the paper in varying degrees, much like low relief sculpture. The persistence of the intense, dazzling colors works with the contrasting soft modeling to maintain surface unity.

DAY 11
Shorthand Diary

As students master the theory and technique of painting, they tend to spend more and more time obsessively planning compositions, deliberating over every brushstroke, and working long and hard to make paintings *look* spontaneous. This is part of the learning process, and your paintings usually will improve, despite a little overworking now and then. But today I insist that you lay down your education for a brief time and begin a diary of sorts, in which watercolor is practiced as it is best defined: a quick, fluid vehicle for recording both moving and static events. I am not necessarily speaking of sketching ideas for future paintings, or just painting practice, but a flurry of serious works, quickly sighted and quickly rendered with as little clutter as possible between your mind's eye and your hand. These little painterly glimpses of your life can be as fertile and inspiring as your most deliberate painting.

Recently, I stumbled on the David Hockney/ Stephen Spender collaboration, *China Diary*, in which Hockney, the contemporary British artist, illustrates the poet Spender's prose during a trip they made to China. His many watercolors, in their stunning, abbreviated bursts of color and marks, reveal an artist enjoying, quizzing, commenting, seeing, and painting, uninhibited and direct, powerfully depicting each subject in its essence. This is what we lose when we assume that quality in a painting is somehow measured by the time we spend making it.

Exercise: Watercolor Diary. You can use a bound journal of watercolor paper, or you may divert some energy and time into designing and assembling one yourself with your favorite paper. These periodic endeavors could also be painted on loose sheets and stored in a portfolio, but keep them separate from your other work. They make up your diary and, kept intact, will be gratifying to leaf through in the future. Whatever format you decide on, take the diary with you to a site where people move about and congregate, such as a park, campus, or other public grounds. Start to make little paintings of the people and animals about you, capturing their movements or

resting poses. Paint what you see and sense as directly as you possibly can. Don't worry about anything except doing. You may make separate compositions or just stuff some pages with gestures and ramblings. Do them quickly; try not to spend more than three minutes on each painting. Vary your color concerns as much as you can from sketch to sketch. When you are tired of painting figures and animals, look at the forms of the landscape and repeat the process. Finally, take your work back into your studio, or kitchen, or any room in your dwelling, and paint found still lifes and intimate interior spaces.

Try not to write too much in this diary; let it be a visual accounting of your life and surroundings. Return to work in it whenever you are worn out by the burdens and responsibilities of making Art. As you paint these little works, have faith that even though you are not analyzing every motion, the knowledge you have acquired in previous, more labored pursuits will leap from your brush in color and form, singing the essence of what you see and feel.

Mohd. Salim Hassan, student work, 11" × 15" (27.9 cm × 38.1 cm)

There is lively gesture in the brush of Salim Hassan. On this page of figure studies he has sketched, with great confidence and a rich palette of grays, the walkers, bikers, sitters, and ballplayers that inhabit our campus. His use of broad washes surrounding the vignettes has the effect of unifying them into a casual composition.

Mohd. Salim Hassan, student work, 11" × 15" (27.9 cm × 38.1 cm)

Mohd. Salim Hassan, student work, 11" × 15" (27.9 cm × 38.1 cm)

Here is Salim Hassan's page of landscape sketches, painted with the same vitality as the figures. Salim usually deliberates over his paintings for hours and is always the last to leave class, but when assigned these sketches, he adapted his technique accordingly. He assures me that he remained well within the three-minute limit for each painting. I suggested that some of this instantaneous response could be filtered into his lengthier enterprises.

This last page of Salim Hassan's sketches is filled with some impromptu still lifes. More aggressive light and color play over these objects, perhaps because of the harsher incandescent light indoors. I especially admire the paint handling in the two pairs of objects at top left and center. Once again, Salim draws the sketches together with fluid connecting washes.

Michael Crespo, THE FLICK AND QUEENIE SCROLL, sumi and watercolor, 12″ × 23″ (30.5 cm × 58.4 cm)

Michael Crespo, THE FLICK AND QUEENIE SCROLL, watercolor, 12″ × 24″ (30.5 cm × 61.0 cm)

Michael Crespo, THE FLICK AND QUEENIE SCROLL, sumi ink and watercolor, 12" × 23" (30.5 cm × 58.4 cm)

These three paintings are sections of an ongoing chronicle of my two beloved young rat terriers at rest and play. The puppies make difficult but fascinating models. In the section at top left, I first sketched them rapidly with a sumi brush dipped in sumi ink. Then I made the color notations with watercolors. These antics are painted on a continuous scroll of sumi paper, which gives that characteristic blurry edge to the wetter ink and color. I calculate that when I'm done, I will have about 25 feet of puppy antics recorded on this particular roll.

In another section of the scroll (below left), I sketched the dogs first with lines of red watercolor and then emphasized certain movements and edges with blue. The smudges of yellow, blue, and violet washes were casually laid in to inject a sense of overhead light. This passage of primary colors sparkles in comparison to the muted hues I used in painting the rest of the scroll.

In yet another expanse of the continuing painting (above), I filled the paper with one image of sleeping pups formed with rapid gestures of a loaded brush. I grayed the color with sumi ink to parallel the muted brushwork and visually quiet the scene of slumber.

Vivid analogous colors load Vivian Beh's brush in her sketches of various flora that interested her. Her talent and skill with the brush are evident in the expressive calligraphy that modulates equally expressive color from form to form.

Vivian Beh, student work, 7½" × 10" (19.1 cm × 25.4 cm)

Vivian Beh, student work, 7½" × 10" (19.1 cm × 25.4 cm)

Birds, bugs, and bystanders inhabit another page from Vivian Beh's sketchbook. First she records them in flat, animated shapes. Then she may drop in another color or two or scribble in some lines of definition, as in the insect at bottom right. The standing man makes a stable center for the circle of characters dancing about on the white paper.

Steve Erickson loitered about the sports complex on campus to track down subjects for this page of sketches. He contrasts heavy-handed strokes with soft, wet passages to capture the action of life around him. With a puddle here and a line there he also provides surroundings for each of his players, isolating them in their own little arenas.

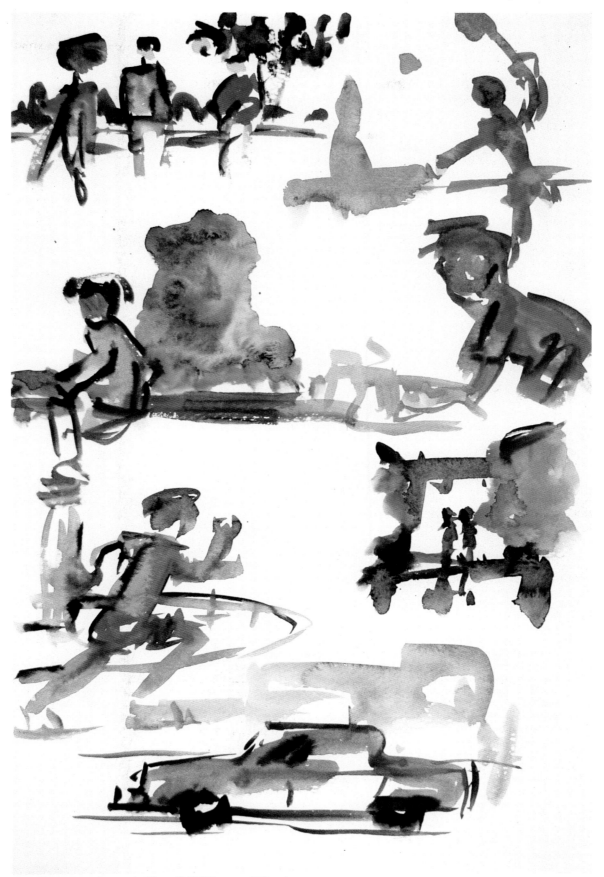

Steve Erickson, student work, 17″ × 11½″ (43.2 cm × 29.2 cm)

Maureen Barnes, student work, 18″ × 24″ (45.7 cm × 61.0 cm)

Maureen Barnes constructed a grid to house her studies of landscapes, figures, and interiors. The rectangular formats make decided compositions of the casual sketches. Maureen forsakes the ease of random placement and is forced to consider her forms in relation to four edges in each of the fifteen little episodes. It did not seem to inhibit her, for the subjects are fresh and lively as well as thoughtfully composed.

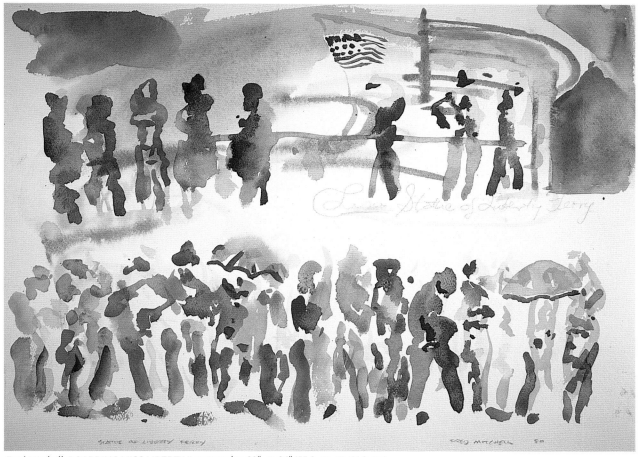

Fred Mitchell, BOARDING MISS LIBERTY II, watercolor, 22″ × 26″ (55.9 cm × 66.0 cm)

Shaun Aleman, student work, 12″ × 12″ (30.5 cm × 30.5 cm)

Fred Mitchell rapidly records a throng of people lining up to board a boat. His perceptive eye and talented hand transform abstract strokes and a maze of colors into a very believable depiction. It's really a great lesson in painting the essence of a subject rather than trying to render its parts, an approach that is especially useful when time is limited and the scene is crowded.

On this sketchbook page, Shaun Aleman uses three linear sequences to quickly grasp his various models. In the top row, he lines up heavily modeled trees and deep space panoramas. In the middle line, he warms his palette to delicately record both interiors and still lifes. And at the bottom, he paints cartoonlike lines and colors that effectively animate his figure studies. His compositional decision to make three distinct rows of subject matter also influenced the three tiers of different techniques and colors.

DAY 12
Horizons

Although we often speak of the horizon, or horizon line, when discussing landscape paintings, the landscape itself, or even still lifes and interiors, the term itself is somewhat ambiguous. As painters, we have two definitions. The apparent junction of earth and sky is what we call the "visible" horizon line; the "actual" horizon line is your eye level, or the imaginary line drawn as you look straight out into space at right angles to the vertical. It is possible for the two to be one and the same, although it is not usually so. Your work today will dwell on the actual horizon, for that is the key to understanding how to draw space as you, the painter, stand in it.

It is instructive to see how the dimensions and proportions of an object change as your eye level shifts. Place a clear water glass on the edge of a table. View it first with your eyes level with the surface of the table. Rise, keeping your eyes on the glass, and note what happens to the front surface and the ellipse of the rim as they change form with your movement. Repeat, moving downward until you're sitting on the floor. You have just witnessed the fundamentals of basic perspective, and although I would never try to make you plot the world in linear perspective, it is important that you grasp a little of how it works.

Exercise: Shifting the Horizon. Today, I want you to make two paintings, the first illustrating a *high* actual horizon, the second a *low* actual horizon. For the first, find a spot overlooking the landscape. Go out and paint from a mountaintop or hill, or paint from your roof or the top of a building. Go paint in a tree if you like; just be sure to get your eye level up there so you can look down on a lot of things. For the second painting, I suggest you find a fairly flat area and sit on the ground to paint. Lying on the ground would be even better, if you can figure out a way to paint comfortably. Wherever and however you decide to paint, be sure the two paintings clearly depict opposite positioning of the horizon.

In this sketch of an unobstructed horizon, the visible and actual horizons are one and the same.

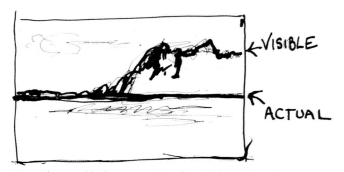

Now I have added a mountain; the visible horizon becomes the line along the top of the mountain moving down to the left over the boulders at its foot. The actual horizon is still visible and remains the same.

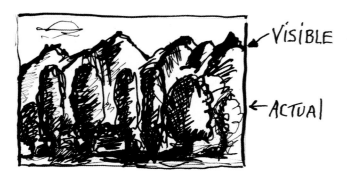

More mountains and trees obscure the actual horizon line, but its position remains the same, whether you see it or not. The visible horizon is now the heavy line marking where the peaks meet the sky.

One-point linear perspective. The black square indicates one side of an object. Draw straight lines from the corners of the square to a vanishing point at your eye level (the actual horizon). Then construct the rear edges with vertical and horizontal lines that intersect on the vanishing lines; simply estimate the depth of the object. The eye level is high for the bottom box, low for the top one.

Two-point perspective. A corner edge of a form is indicated by the heavy black line up front. The two sides vanish to different points on the actual horizon line. Simply draw straight lines from the top and bottom of the given vertical to each vanishing point. Estimate the depth with vertical lines (marked with little arrows). Draw the top by extending lines from each vertical to the opposite vanishing point. This drawing illustrates perspective from an eye level above the box.

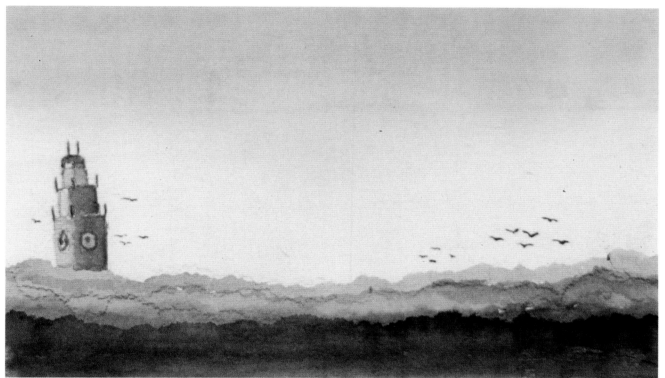

Marvin Carter, student work, 5" × 8½" (12.7 cm × 21.6 cm)

Marvin Carter paints from an unusual viewpoint at the same level as the birds he has strewn across the treetops. The space seems bizarre because his eye level is a little below the visible horizon line, and both horizons are low in a painting done from high above the ground. The birds establish the scale, as does the tower that stands alone in bands of treetops painted like choppy waves at sea.

Rob Jarrell, student work, 7½″ × 11″ (19.1 cm × 27.9 cm)

Rob Jarrell got low on the ground to paint this bleached view down a street. The parked automobile and building are extremely distorted because they vanish to points on an actual horizon so low it is almost out of the picture plane. Rob lets his concise drawing dominate by painting with rather scant amounts of very limited color.

Van Wade-Day painted this very graphic linear landscape while perched high on a hill in the English countryside, with what must have been an exhilarating panorama before her. From the point of view clearly evident in her perspective, I would venture to say that the high actual horizon corresponds to, or is very near to, the visible horizon at the top of the picture. The ledge on which she worked is visible at the bottom, giving us another reference to the artist's location in the landscape. Notice how she isolates warm colors in the middle zone, sandwiching them between the cool tones in the background and on the foreground ledge. This empha-sizes the deep space even more by defining three distinct zones of space.

Van Wade-Day, LANDSCAPE AT ROSTHWAITE,
watercolor, 10½″ × 7″ (26.7 cm × 17.8 cm)

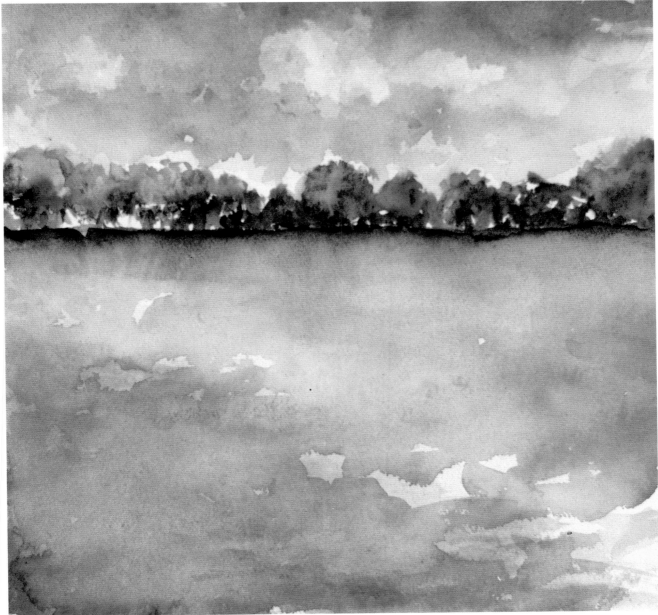

Elizabeth Jenks, student work, 11″ × 11″ (27.9 cm × 27.9 cm)

Elizabeth Jenks's eye level is the line at the base of the trees, and there is a visible horizon where the sky meets the tops of the trees. Both are situated high in the painting, leaving a large expanse of unpopulated foreground to be kept flat. It would have been easier to locate the tree line low in the painting, but Elizabeth tackled the problem and solved it with subtle maneuvers on the ground plane. Well-positioned abstract shapes, nuances of wet-in-wet technique, a pool of glowing light, and a diagonal line marking where a giant cool shadow turns to yellow heat—all help keep the vast foreground lying flat for us to skate across, leading the eye back into the trees.

DAY 12: Horizons

In this vacation painting, Jack Knopp paints an almost unobstructed view of the classic horizon far out in the sea— the actual and visible horizons are the same. It's obvious that the diagonal lines of roof and porch vanish to points along the line where yellow sky meets blue water. The painting is fresh and light-filled; the vibrant red chair and pocket of concentrated light that surrounds it form a distinct central focus.

Jack Knopp, THE RED CHAIR, watercolor, 10″ × 16″ (25.4 cm × 40.6 cm)

Scot Guidry got the idea for this painting while lying down in a field recovering from a game of lacrosse. It's nice to know that some students are always thinking of painting! The actual horizon line is probably about one-third of the way up the cup, while the visible horizon is higher up, along the distant tree line. The depth of the space is dramatically depicted—a paper cup is the same size as a high-rise dormitory; a line of grass is larger than a line of trees. The arched wash of the sky makes this particular staging of space even more grandiose and absurd.

Scot Guidry, student work, 11½″ × 15½″ (29.2 cm × 39.4 cm)

The horizon line is brought indoors in this still life of bitter color and acute light. There is a strong visible horizon along the back edge of the table, but the fact that we see so much of the top of the basket-shaped object indicates that the actual horizon is much higher, out of the picture plane. The clarity of the space in this painting is staggering, and the peculiar color, light, and objects breathe a surrealistic air into this scene on an arid tabletop.

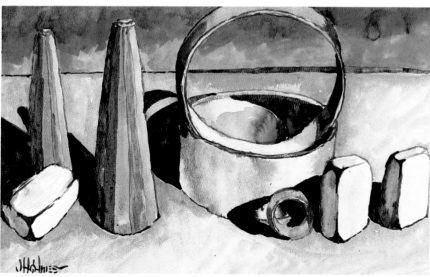

Joe Holmes, student work, 10½″ × 16″ (26.7 cm × 40.6 cm)

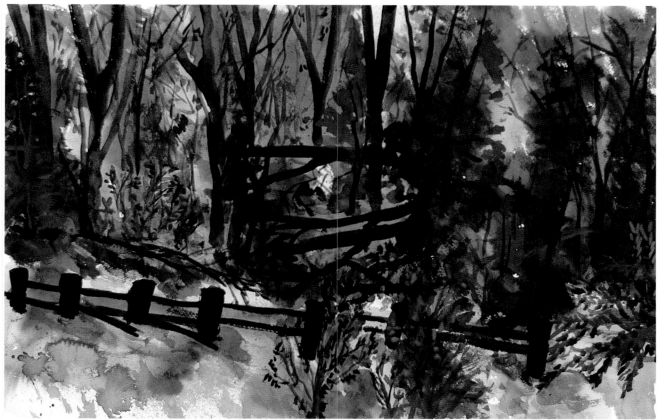

Patricia Burke, student work, 15" × 22" (38.1 cm × 55.9 cm)

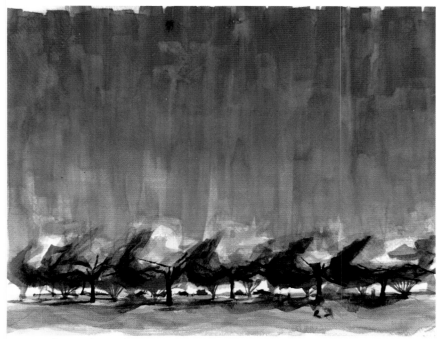

Robin Viallon, student work, 15" × 20" (38.1 cm × 50.8 cm)

Dramatic backlighting and the primary triad give life to this woodland scene by Patricia Burke. There is no visible horizon in the cluttered view she chose to paint. We are given a clue to the actual horizon by the plane of ground just in front of the fence. This indicates that she was looking down, with her eye level near the top of the painting. The heavy black lines that contrast with the sharp explosions of red, yellow, and paper-white are as thrilling as the marks of the exuberant hand that painted this excitement.

The actual horizon is low, as is the visible horizon, in this painting by Robin Viallon. Very active paint and color contradict the placid composition of this scene. The commanding vertical strokes of the sky seem to rain the yellow light down onto the treetops and the ground. Along what appears to be the actual horizon, Robin uses paper-white, bright cobalt blue, dark tree trunks, and red-clothed people to articulate the ins and outs of the arcade formed under the trees.

89

DAY 13
Light of Day...and Night

Claude Monet, the great French impressionist painter, was obsessed with the way light in the landscape changed during the passage of a day and the effect this changing light had on color and value in painting. He made more than thirty paintings of Rouen Cathedral, recording the different impressions light made on the massive facade at different times of the day. The hue, intensity, and value all changed. Shadows shifted position, shrinking and swelling as the earth changed its position in the sun's light. You are probably also familiar with Monet's series of paintings of haystacks in the fields, in which he studied the changing colors produced by light as it drenched the French countryside.

Trees are green; their trunks are brown; the sky is blue. These are examples of local color, which is defined as the actual color of forms in the light of day. In truth, it's more a fixed concept than a product of perception. Monet found that the light of day and the colors it produces are constantly changing. He used what is known as optical color, which is the color we perceive an object to be in a given light situation. It may be the color at high noon, just about midnight, or under a fluorescent light. Color is in light's domain: the light changes, the color changes. Optical color is our concern today. Incidentally, there is another kind of color we make use of as painters, one you already explored on Day 8—arbitrary color.

In the morning, the cooler, less intense hues generally saturate the landscape. The value range is subdued in the very early hours but expands as the light increases. As the day moves on, the cooler colors begin to warm up, just like the air, but they seem to become less intense around noon. This is because the sun is directly overhead, lighting forms more evenly, which reduces the contrasting shadows. Color intensity and value contrasts steadily increase

to full crescendo in the late afternoon, when dark, cool shadows stretch out in dramatic contrast to the hot orange light. And occasionally at dusk, when the shadows disappear, the earth becomes a cool, flat silhouette pressed against a sky of pink, orange, and red-violet from the waning sun. This breathtaking excess of nature is known as crepuscular light. I stress that these general observations are not always certain. Weather can be a great spoiler or enhancer of optical color effects. Think about the color of the landscape on overcast days, or before a raging storm, or in rain itself. Everything changes as we move around the world. Henri Matisse traveled the globe searching for the perfect light. For this problem, you'll only have to go into your own backyard.

Exercise: Capturing Changing Light. Go out in the landscape—your backyard is perfect—and find some structure or object to paint, such as your house, a garden shed, a tree, a chair, a birdbath, or perhaps a simple still life set up outdoors. Choose three distinctly different times of day to paint your subject. Scrutinize the color and value carefully, and record what you see as accurately as you can. If you're painting deeper space, you may notice how the aerial perspective changes. You do not have to do all these paintings in one day. Some students burn out from staring at one subject so long. And by all means take advantage of any interesting weather effects, like storms, fog, mists, sleet, or snow. (Being a deep Southerner, I'm not too well versed on the last two.) Don't hesitate to go out and paint at night, either. James Abbott McNeill Whistler's splendid nocturnes should inspire you. Your investigations of the light of day and night will supply you with many discoveries, directing you to a more thorough approach to the majesty of light.

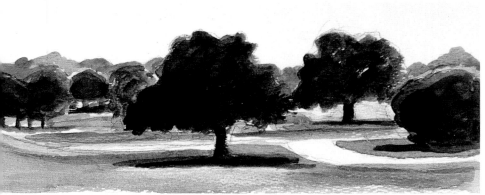

Libby Johnson Crespo, CITY PARK GOLF COURSE, EARLY MORNING, watercolor, 4" × 10" (10.2 cm × 25.4 cm)

I enlisted my wife, Libby, who is an accomplished landscape painter, to make some small sketches from a single point of view and record the effects of the light. She made this first painting in the early morning, from a vantage point looking due east into the rising sun. There was no sky color; the sunlight was white. Forms were backlit because of her position, and the colors had a bluish cast. The dense humidity was visible, permeating the atmosphere, and natural aerial perspective was more obvious than at any other time of day, at least in this part of the country.

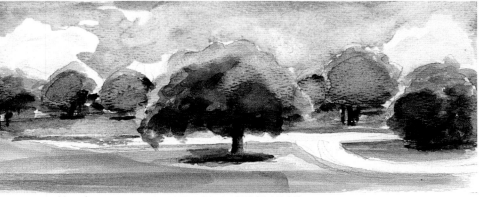

Libby Johnson Crespo, CITY PARK GOLF COURSE, NOON, watercolor, 4" × 10" (10.2 cm × 25.4 cm)

At noon, Libby found the trees lit strongly by the sun above. This direct overhead light produced small shadows directly under the forms. Colors were considerably warmer than in the morning and slightly bleached. The sky appeared blue. The values were fairly evenly dispersed over a wide range.

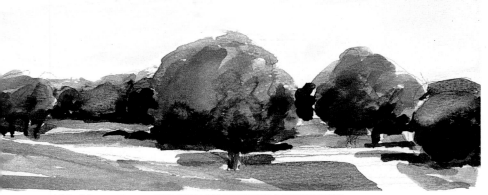

Libby Johnson Crespo, CITY PARK GOLF COURSE, LATE EVENING, watercolor, 4" × 10" (10.2 cm × 25.4 cm)

In the evening, the sky changed from blue to a warm yellow-orange. The value range increased dramatically because of the lower angle of the sun, which threw long shadows out behind the trees. Color was at its warmest, with the deepest shadows beginning to cool in contrast.

DAY 13: Light of Day . . . and Night

Joe Holmes chose an ornamental bird-bath in his yard for subject matter. He decided to paint all three paintings in the late afternoon and evening. I quote him directly: "I had been wanting to paint this birdbath in the late afternoon for some time, and when Michael suggested painting one subject at different times of day or weather, I dove in. I faced the sun directly, because I wanted that glow behind the bath. The secret was to butt bright yellows against darker violets, changing not only value but temperature, and keeping some edges sharp."

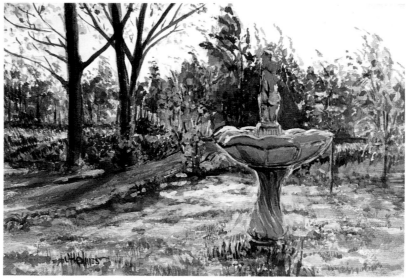

Joe Holmes, student work, 9" × 13" (22.9 cm × 33.0 cm)

The day moved into dusk for Joe's second treatment of the subject. Again I quote from his notes on these paintings: "At sunset everything is low-key. It seems that no matter what I did, the light and color of the sunset itself were more important than my subject, or any subject. In this painting, the birdbath is secondary."

Like most of us, Joe was enraptured by the stunning orange and violet light that can permeate the late evening. This is known as crepuscular light.

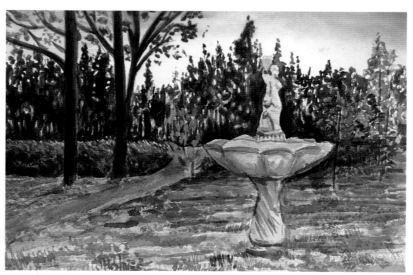

Joe Holmes, student work, 9" × 13" (22.9 cm × 33.0 cm)

For his final painting in this series, Joe actually sat outside and painted in the dead of night. It can be a unique painting experience, and I heartily recommend it. He had these comments scratched on the back of this one: "I was overwhelmed at finding that I *lost* so much detail at night. What the afternoon revealed in such sharp contrasts of violet and gold and green became an indistinguishable mass of blurred foliage. The light on the utility pole in my yard was all the light that I had to paint by. I more or less guessed at some of the colors I used. I'm quite pleased (and surprised) at the results."

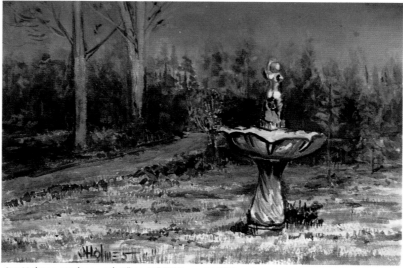

Joe Holmes, student work, 9" × 13" (22.9 cm × 33.0 cm)

Steve Erickson, student work, 7½″ × 10½″ (19.1 cm × 26.7 cm)

Jack Knopp, VIEW OF THE LSU CAMPUS, watercolor, 12″ × 16″ (30.5 cm × 40.6 cm)

Steve Erickson painted the dark silhouette of a neighborhood bordering a lake in his nocturnal painting session. Although color is virtually absent in the scant night light, Steve painted more than he could see, generating a subtle but fertile fabric of hues. The foreground plane alone contains traces of red, blue, green, red-violet, blue-violet, and various grays. He used opaque white to paint the clouds, the street lamps, and the dots of window lights and their reflections in the still lagoon.

Jack Knopp painted this liquid view of the campus in the middle of the day. There are no shadows cast on either side of the forms; the sun is directly above. His color conveys the bleached look of high noon in a Louisiana summer. The painting is thoughtfully organized; the eye is carried through its various zones to the tower in the back. This is partly achieved by using a broad value range within a very limiting high-key system.

Stanley Sporny, THROUGH THE PARK, watercolor, 22" × 30" (55.9 cm × 76.2 cm)

The light of day is never predictable. Sudden changes in weather condition, or just the obstruction of the sun by a passing cloud, can completely transform the existing light. Stanley Sporny paints the mysterious light after a storm with lush encounters of warm and cool color. These contrasts, which reflect off puddles in the saturated earth and weigh heavy in the air, are born of a neutral light in the center of the sky. Stanley uses a luxuriant wet technique for the sidewalks of this English park traversed by passersby who ignore our spying eyes.

The light of late evening is resplendent in this harbor scene by Fred Mitchell. The orange of the sun melts into a pink band that infiltrates the powerfully contrasting cool blues and greens of the water and the rest of the sky. The distant city, the clouds, and the boats are painted gray, as if overwhelmed by the radiance of the light. Tiny defined flecks of color are built up over big wet washes for further contrasts of scale and technique. There is no doubting Fred's mastery of the medium—his brush has danced about with limitless versatility to produce this glorious depiction of light and place.

Fred Mitchell, TWO DEPARTING HARBOR, watercolor, 14″ × 20″ (35.6 cm × 50.8 cm)

Orlando Pelliccia, 1235 MAGNOLIA, watercolor, 34″ × 26″ (86.4 cm × 66.0 cm)

Orlando Pelliccia was a visiting artist here for two years, and he roamed the neighborhoods on the fringes of campus painting the architecture. He would brazenly set up shop in the neutral grounds of busy boulevards in order to paint *in situ*. This ably rendered facade was made in late evening on a winter day when nature's display was not as spectacular as we have seen in the other paintings. The distinct value of the light sustains the repressed drama. Orlando is a meticulous draftsman who paints with unrelenting efficiency and clarity. Here the subdued colors of the houses and environment almost seem to be cut out and pasted on the white light of the chilly evening sky.

DAY 14
Water

Early in the morning, I walk down to the small pond behind my house. A large-mouthed bass is spawning in the shallow water near the bank. The usual morning winds have not been aroused yet and the water's surface is tranquil, perfect for viewing its submerged inhabitants. Looking beyond the mirror image of the sky reflected in the pond, I spy the fish hovering over a dark circular depression, her nest. The soft edges and indistinct surfaces of their forms are comforting to observe. Something alarms her—perhaps it is my presence—and she turns and darts, her swirling dorsal fin breaking the surface. I can still see the fish, but I am momentarily distracted by a rippling pattern of dark and light values on the surface that she sliced. Sparkles of light appear and vanish in the swells and valleys. The image of the sky is no longer discernible. I can still see the fish, but now she is distorted, her image transformed by the disturbances of the surface. As a breeze suddenly begins to blow, broken rows of pulsing rhythms of value and color march in endless procession across the entire pond, erasing all that is submerged. My fish-watching is ended, but I have had a thorough lesson in painting water.

Water, like drapery, appears repeatedly in various subject matter, from seascapes to rain-drenched streets to vases of flowers. It can be painted with very little thought and with any technique and color if there are enough narrative references. After all, what would we call that purple plane those children are playing in just on the edge of the sandy beach? What is that gray stuff the boat is sailing through? But water does manifest some very basic special effects that we are able to translate into watercolor. You will be dazzled by the incredible water illusions some artists are able to render. You may stumble on some stunning ones yourself, but today let's consider some simple approaches to depicting this sometimes elusive element.

Exercise: Painting Water. Make a painting of a large body of water. If you have no access to a lake, pond, or river, paint at a swimming pool or even a large fountain. The water should dominate as subject. Carefully scrutinize its surface qualities and develop some simple method of rendering it. Note reflected images, if there are any, as well as submerged objects.

Exercise: Still Life with Water. In a second painting, find a way to use water as the commanding element in a still-life setup. Think about this one awhile, for you may arrive at a very novel solution.

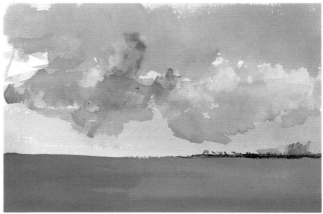

A plane of color serves as the undisturbed sea stretching into the distance. I've varied the value to indicate varying depths, but a flat wash would also have worked. The shoreline and sky provide the references to identify the plane of color as ocean.

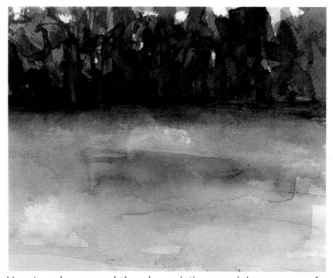

Here I made some subtle color variations, and the nuances of the wet-in-wet technique indicate activity beneath the surface. Vague murmurs of light or submerged objects are visible.

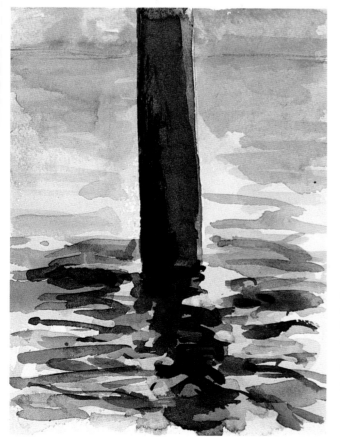

The water's surface is paramount in this little scene (above left), as it mirrors the world above. In most situations, reflections will have softer edges, less intense color, and closer values than what they reflect. On a perfectly brilliant day when the water is as still as glass, you might observe and paint an identical mirror image. However, the surface of the water in this painting is moving slightly, as indicated by the slight distortions in the reflections.

The circular strokes, built up in layers, indicate an interruption in the natural flow of the water (above right). I laid in a light green wash, let it dry, then worked methodically toward the surface with layers of value, graduating to the darkest value at the top. The lighter marks appear to be shadows beneath the surface of the water, echoing the darker agitations above.

I often use monochromatic color to depict water, but in this example (left) I used short, choppy strokes of a number of colors for the backlit reflection of the pole in this restless surface. The brighter colors and strong value contrasts refer to a more brilliant light of day. Notice also the aerial perspective produced by diminishing the color, value, and edges of the foreground strokes as the plane of water passes beyond the post and toward the horizon.

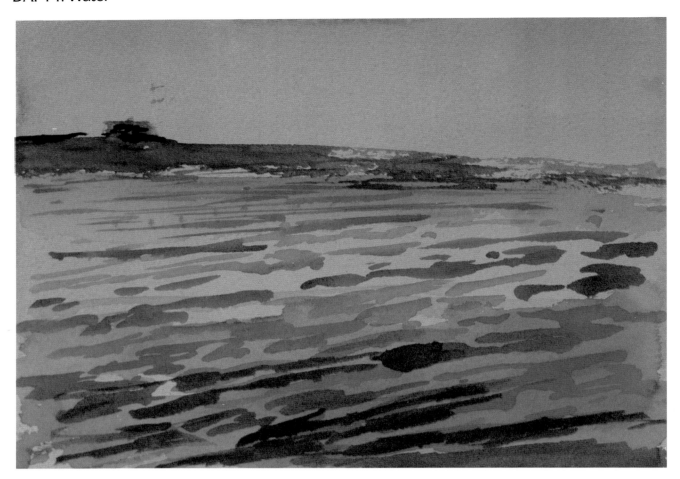

A steady wind makes a gentle chop on this bay water. It was painted by laying down a light blue wash, allowing it to dry, and then making the fairly regular diagonal strokes of darker values. Often, as is the case here, the water will reflect the exact color of the sky. In this painting, the sky was part of the original wash.

The problem here was to render submerged objects fairly distinctly, while at the same time depicting the surface. I accomplished this by first painting the fish and the green of the water onto wet paper, keeping their edges very soft but marking strong darks to keep their forms visible. After letting it dry, I took a brush with some darker green pigment and drybrushed it over the entire surface in horizontal stripes. I then applied some milky shapes of dilute opaque white before painting the sparkling highlights with full-strength white.

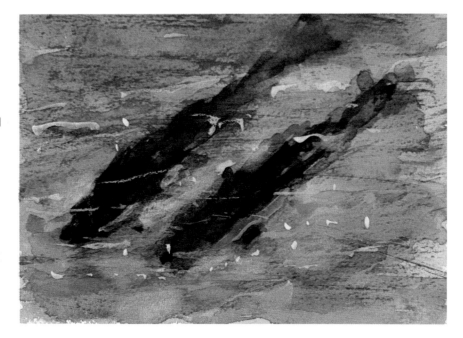

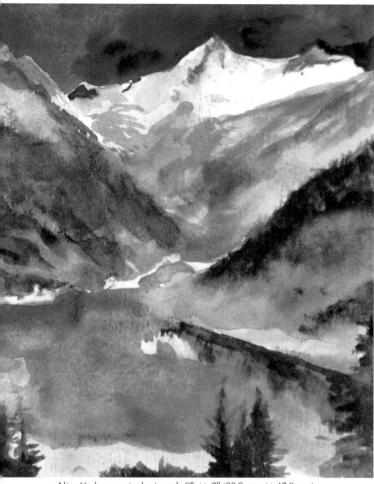

Alice Verberne, student work, 9″ × 7″ (22.9 cm × 17.8 cm)

Alice Verberne paints a body of water trapped high in the Alps. She renders the water with the same soft, wet strokes that dominate the rest of the painting. The reflections of the blue of the sky and the diagonal image of the green trees near the left shore add to its watery appearance. The jagged whites of the snowy peaks are also found in a solitary reflection on the surface. The frilly evergreens popping up off the page at the bottom make a very effective framing device for the heavy atmospheric forms beyond.

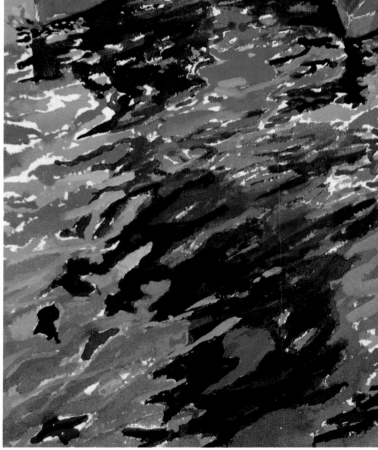

Libby Johnson Crespo, CATYAK REFLECTIONS, watercolor, 7″ × 6″ (17.8 cm × 15.2 cm)

My wife, Libby, lost herself in the sizzling reflections of an approaching catamaran, whose twin hulls enter the picture at the top. The fractured image was caused by a steady wind across the water's surface. With a discerning eye and a direct, robust technique, Libby captured the raucous abstraction of harsh color and value. She used three values of blue and the glistening white of the paper to lay down the primary field of reflected sky, then punctuated it with two values of red and one of black.

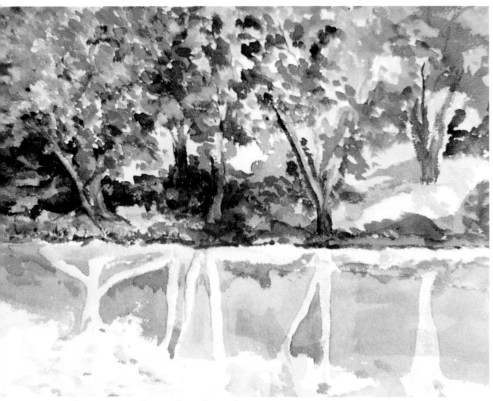

Leslie Wagner, student work, 13½″ × 16″ (34.3 cm × 40.6 cm)

Leslie Wagner makes a strong distinction between forms and reflections in this lakeside painting. It's obvious that she delighted more in rendering the landscape above the water than in painting its reflection. Her flurry of facile dabs and strokes defines a wonderful scene ablaze with color and definition. I expect satyrs and nymphs to appear in the cool shadows beneath the trees. The image in the water is an enormously diluted version of the shore; the likeness is not completely lost, however, for the tree trunk reflections are strongly defined as white counterparts of the dark trunks above. The drift of red in the foreground also helps to draw it all together. The water is not weak in its understatement; in fact, it is a bold contrast.

Mylene Amar uses subtle color and brushwork in the large foreground plane of water in her painting. She achieves a reflective surface with a combination of broad, soft washes and some very nervous linear calligraphy. These marks do not reflect any of the forms on the bank but shatter the plane of water, producing the effect of reflected light on its surface. Mylene has also reversed aerial perspective, moving from an almost imperceptible foreground to a focus in the deep space.

Mylene Amar, student work, 14″ × 9½″ (35.6 cm × 24.1 cm)

Scot Guidry made water a force in his still life by immersing a cup, saucer, and spoon in a bathtub full of water. The resulting painting is a humorous and provocative exaggeration of the assignment. The curious linear treatment of the objects was achieved by sketching with watercolor pencils, which bled somewhat as he developed the fuzzy surroundings. The lilting blues and greens were painted into paper so wet there were puddles standing on it. The yellow and faint red traces of the watercolor pencils electrify the subject of this outrageous submersion.

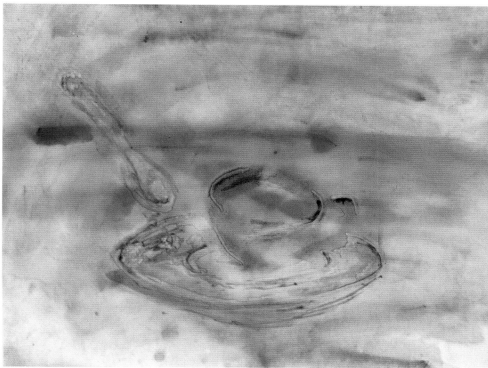

Scot Guidry, student work, 11″ × 15″ (27.9 cm × 38.1 cm)

Joel West introduced water into a still life by pouring water into objects that he likes to paint and positioning each so that it displayed its aqueous contents. The water in the large dish is almost imperceptible except where the spoon breaks the surface; this discontinuity is marked by irregularities and added color. His rendering of the water in the warm-hued goblet is similar to his handling of the goblet itself; the point here is that the water's surface can at times resemble that of highly polished metal. Small unidentified objects are submerged in the water of the blue glass vase, reflected and refracted in such a way that they fill the form with abstract patterns.

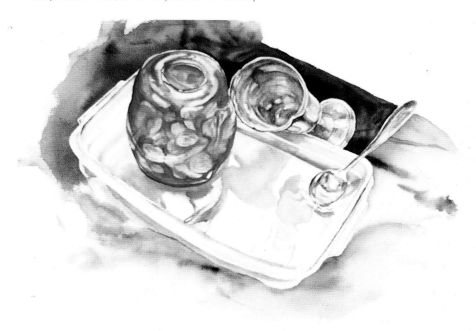

Joel West, student work, 14″ × 20″ (35.6 cm × 50.8 cm)

DAY 15
Processes of Abstraction

Abstraction is the alteration, distortion, or simplification of subject matter. Unlike nonobjectivity, it is the result of observing or experiencing our environment. As painters, we all use some degree of abstraction. We distort the three-dimensional world when we translate it onto a two-dimensional piece of paper. We remove the entire dimension of depth and then restore it in a multitude of illusions. I maintain that *all* painting is abstract; however, the term "abstract painting" refers to a composition in which the painter is more concerned with manipulating the formal elements (color, value, line, shape, and texture) than with realistically rendering the subject matter. The painter observes ordinary objects in space and depicts them in new and exaggerated ways on paper. Recognizable objects are either veiled or completely transformed. You did this when you painted a still life from multiple viewpoints. Today, you will try three more processes that result in abstract paintings, but instead of painting abstractly from a real subject, you will paint descriptively from abstract subjects: one you will find, another you will arrange, and a third you will construct.

Exercise: Cropped Composition. For the first painting, make one of those little compositional peepholes everyone used in basic drawing class. It's just a little one-inch rectangle cut in a piece of mat board or heavy paper. You look through it to isolate compositions from their surroundings. Use yours to find a composition that is absolutely unrecognizable and abstract. For example, right now I have a portion of the rough oak grain in the top of my desk sighted in mine. I could paint this tiny composition quite realistically on a large piece of paper and have a

dazzling abstract painting. Once you have isolated an image you like, go ahead and paint it. It's not necessary to handle the paint in a hard, realistic way. Paint as you would from any subject, and feel free to let go and push things a bit.

Exercise: Obscured Still Life. For the second painting, I would like you to assemble a still life, arranging the objects in such a manner that any reference to what they are is destroyed. This can be achieved by stacking them so they hide key parts of one another or by masking out areas of the setup with fragments of paper or strips of fabric. A little creative lighting can also conceal identities. One of my favorite solutions is to shroud a still life in heavy clear plastic wrap like that used on greenhouses. When this is brightly lit, some very bizarre effects are produced. Play around until you successfully destroy the original setup and then paint what you see.

Exercise: Constructing the Subject. The final setup involves you actually constructing an abstract sculpture of sorts. With a tube of super-glue, or one of those hot glue guns, and a wide array of junk, you can put together an interesting construction. Or you can make a nice little arrangement of geometric shapes by scoring, bending, and taping together scraps of mat board. Consider applying paint to your construction. The field here is wide open; the possibilities are endless. Have fun composing in three dimensions. Don't get frustrated. It doesn't have to be high art; it's only subject matter. When you're done, make a painting of it. I advise some preliminary sketches to find out a little about it two-dimensionally and to investigate placement on the page.

Dierdre Broussard, student work, 11″ × 14″ (27.9 cm × 35.6 cm)

Dierdre Broussard cropped this flickering moment out of a landscape element. It's a little like looking through crystal beads. I never ask exactly what the subject was in this first assignment; too often the class winds up discussing whether or not a painting really looks like pine bark. Remember, the problem is to transcend the subject matter by lifting it out of context.

Dierdre has created an enormous buildup of translucent colors with a staggering display of marks. A vague horizontal passage is overwhelmed by a host of vertical droplets that resemble rain running down a windowpane. The grays and low-intensity colors predominate, which makes the cobalt blue focus even stronger. It is seconded by the red splotch at the upper right.

Christy Brandenburg, student work, 10″ × 14″ (25.4 cm × 35.6 cm)

In another version of the first exercise Christy Brandenburg puts the primary colors to work in gentle movements of very directional strokes. The leggy marks seem to stretch out in different directions, like plants finding the sun. Yellow dominates, red plays second fiddle, and intertwined wisps of blue and violet are the key focuses by virtue of their sparseness. The color is well tuned. There is no doubt that light dwells here.

Donna Britt, student work, 4½″ × 6½″ (11.4 cm × 16.5 cm)

Donna Britt got this little-piece-of-the-world abstraction from a small portion of filigree on a decorative picture frame. The spontaneous gestures look more like the nova of a blue planet. It's really a very pure and simple painting, with paint transparency providing the luxurious color.

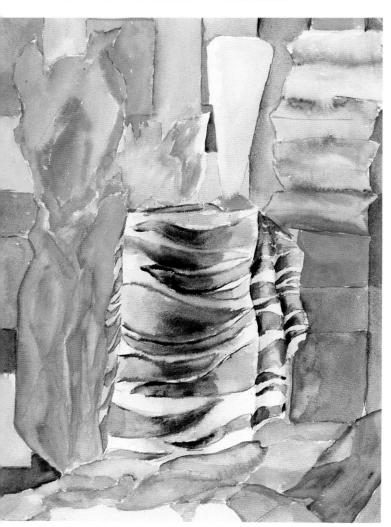

Lisa Schober, student work, 17½" × 24" (44.5 cm × 61.0 cm)

Lisa Schober constructs a still life that completely loses its identity in this response to the second assignment. A sharply lit gray and white central form, wrapped somewhat like a mummy, is flanked by a wide array of colors applied wet-in-wet. The sharp definition and strong value contrasts of the central form distinguish it from its more nebulous, lower-contrast surroundings. The flaming red and orange apparition on the left and the yellow cone on top also claim the spotlight in this mass of amorphous shapes in a geometric space.

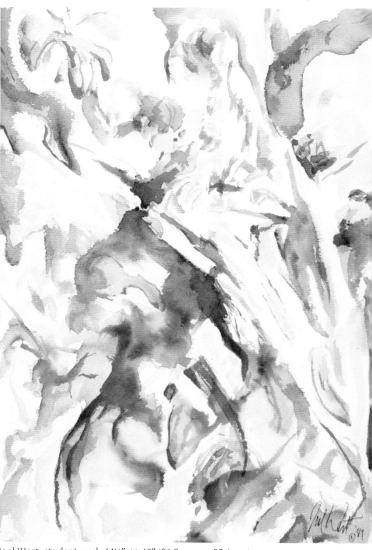

Joel West, student work, 14½" × 10" (36.8 cm × 25.4 cm)

Joel West worked from the same wrapped still life as Joe Holmes (opposite), but he sought out smaller, more abrupt passages. Instead of a large mass on a ground, he has found a field of frolicsome shapes defying any significant organization. His broad range of color is all displayed on the white of the paper, which gives structure to his freedom. His brush must have been burning after all the paces he put it through.

Joe Holmes, student work, 13" × 14" (33.0 cm × 35.6 cm)

Joe Holmes has painted a still life wrapped in clear plastic with the light source inside the transparent film. The outcome is this web of warmth engulfed in a field of a more reluctant blue. Obscured by the plastic, the once recognizable still life is reduced to a melee of vicious slashes. The thinnest lines result from scoring the paper with a blade prior to painting. Hard and soft edges mix with warm and cool colors and light and dark values, and to tame it all there is one small red shape in a tiny puddle of green just above and to the right of the center.

Charles Brown, student work, 22" × 30" (55.9 cm × 76.2 cm)

Charles Brown constructed a simple sculpture of two cones attached to a board to serve as his model for the third painting in today's assignment. He organized the color into two sets of complements: The cones compete with each other, blue against orange, while the yellow background confronts a violet ground plane. This simple, logical structure is undercut and enlivened by the tumultuous handling of the paint. Charles used resists coupled with complicated mazes of daggerlike brushstrokes. And although each form expresses a single dominant color, each major hue is made up of a number of other colors.

I can't help but feel a certain sense of mystery brought on by the banal simplicity of the two geometric turrets and the energy they seem to be stirring up on the table plane.

This painting is one of a series I made painting directly from three-dimensional mat board mock-ups. They were left unpainted, and I used various lighting tactics to produce different visuals. This painting suggests a much flatter space that actually existed in the more elaborate sculptural construction. At the time, I was working with distemper, which consists of powdered pigments ground into rabbit-skin glue. I kept the glue pliable on a hot plate and mixed in the pigments as I needed them. This paint produces a very chalky, matte surface, but it can be remarkably transparent, as can be seen in the central colors. The background Prussian blue is more opaque. Traditionally, the medium is used to produce very flat, even colors, as in my central pink triangle; I scraped back through the layers with a palette knife to produce the surface irregularities because I needed a compositional dispute to further the metaphor suggested in my title.

Michael Crespo, STORM WARNING, distemper, 20" × 18" (50.8 cm × 45.7 cm)

Patricia Burke, student work, 22″ × 30″ (55.9 cm × 76.2 cm)

Patricia Burke fabricated her setup with folded paper and pieces of painted wood. Mists of pale colors surround the accordion-shaped backdrop, which is alive with variations on the primary colors fused together with an impressive wet-in-wet technique. The gnarled surfaces of the wood in the foreground are subjected to an amplified scrutiny that transforms the commonplace into the unreal. Space is marked with diagonals that speed the eye through this energized galaxy.

DAY 16
Chiaroscuro

There are some light situations that exist only in painting: They may be influenced by nature, but they are inevitably resolved in the domain of paint on a flat surface. Such is the system of chiaroscuro, from the Italian words *chiaro*, meaning light, and *oscuro*, dark; it is also known as Tenebrism, from the Latin *tenebrae*, or darkness.

Most of us have seen and painted another extreme light/dark situation: backlighting, in which objects appear dark because they are located between the viewer and the source of light, literally lit from the back. Tenebrism is the reverse of this. Objects are strongly lit from the front. Imagine your eyes not only seeing but also illuminating what is observed with a ray of light that falls only on objects. The rest of the space absorbs the light and remains dark. This is the aspect that rarely occurs in nature.

Some of the great practitioners of Tenebrism were Michelangelo Caravaggio (1573–1610), Georges de La Tour (1593–1652), and Francisco de Zurbarán (1598–1664). It would be worth your effort to research their work, especially the still-life paintings of Zur-

barán; his exquisitely rendered objects emerge crisply glowing from their dark surroundings, good models for our work today.

Exercise: Chiaroscuro. For your venture, select three objects. They should differ in some respects: size, shape, texture, material, color. Arrange them in a row on a black or very dark drapery that continues up the wall behind them. Strongly light the setup from the foreground and proceed to paint. The background material will probably reflect some light. Disregard it and paint the background black. Remember that this can be either black pigment itself or one of the dark mixtures such as alizarin crimson and phthalo green, or burnt umber and phthalo blue. Another possibility would be to lay down separate layers of color until a satisfactory dark is achieved. You may also keep the ground plane a little lighter than the background to provide a visual resting place for the objects. Regardless of your approach, the resulting painting should be one of brightly lit forms resting in a pool of darkness. Extreme light, extreme dark. Chiaroscuro.

This is the system, the exact opposite of chiaroscuro, that many of you are already familiar with. This cup is backlit; it is located between the painter and the light source. A shadow is cast forward by the light that emanates from the white background.

The same cup is depicted with chiaroscuro lighting. It is lit from the front and appears to be enveloped by the contrasting background.

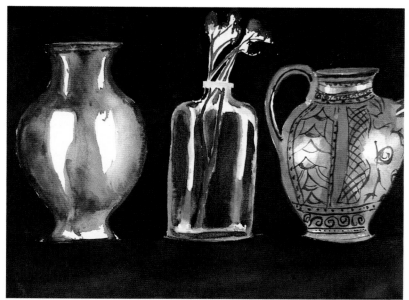

Salim Hassan used paper-white shapes very effectively in his terse solution. He has rendered a wonderful harsh light on the objects, literally making them shine against the background of layered black pigment. He has not indicated a ground plane, but he did draw a bit of the overlapping drapery on the bottom of the objects. This creates a slight distortion but also gives us a reassuring indication of the ground plane. The blatant positioning of the cool glass vase between the two warm pitchers causes the objects to interact. Salim had to use his imagination to make this structural detail work, as the decorative pitcher was white. I always endorse this kind of fudging.

Mohd. Salim Hassan, student work, 11″ × 14″ (27.9 cm × 35.6 cm)

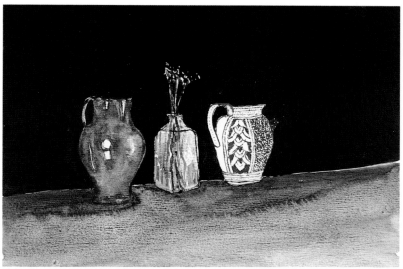

Alice Dommert kept her objects small in order to magnify the surrounding black space. Wet sienna and blue mingle to shape the mottled form of the pitcher on the left. The center bottle echoes the monochromatic gray of the foreground. The pitcher at right is simply blue drawing on white paper; the linear pattern describes the volume. The effect of light bathing objects in darkness is not the only compositional attitude here; the visible horizon line runs across the space as a slight diagonal, making us look sideways at the objects. The downward flow of the ground plane wash gives the poetic impression that the background is melting downward; this top-to-bottom movement plays directly against the diagonal horizon.

Alice Dommert, student work, 11″ × 15″ (27.9 cm × 38.1 cm)

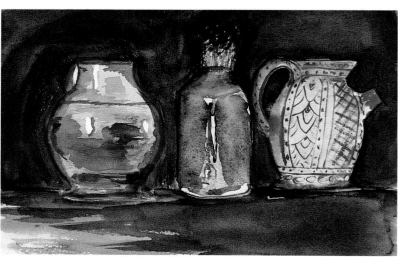

Sabrina Lauga softens the space in her painting by overlaying blues, browns, and grays to yield a shadowy darkness. Her expressive hand allows the objects to sit with a casual air, the strokes of the surrounding space settling them in. Note how she's used a transparent overlapped edge on the orange vase to relate it to the environment. That same muted orange, as well as the complementary blue, lurks beneath the surrounding blackness.

Sabrina Lauga, student work, 8″ × 12″ (20.3 cm × 30.5 cm)

Bryan Murphy has used chiaroscuro and asymmetrical placement to create drama in this study of a woman. Her position at the extreme left allows the stark whites of her form to be located in the center for a very emphatic focus. The value transitions are a series of gradations moving from the edges of the white highlights across the figure and on into the veiled violet shadows. Dull reds and blues add a hint of color while sustaining the darkness of the surroundings.

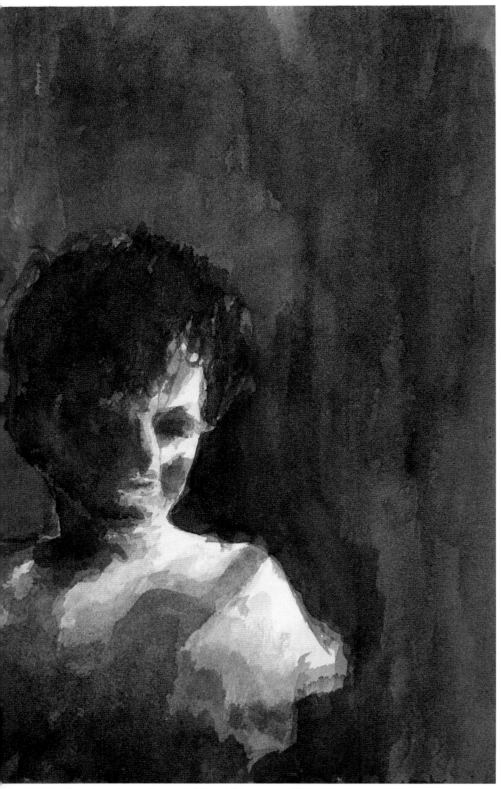

Bryan Murphy, student work, 18" × 10" (45.7 cm × 25.4 cm)

The body of a stunning nude figure descends into dark swirling depths in this painting by Samuel Corso. He overpainted the figure with varying transparencies of the inky stain, leaving the head and shoulders to glow in strong contrasting light. The sharply drawn planes of her anatomy sing out against the murky, ambiguous water. The alternating light and dark under the surface of the water define an arabesque current formed by sweeping gestures of the artist's brush. Color also seems to rise out of the dark ink, gradually unfolding in the full light as a subtle resonance of warmth and coolness.

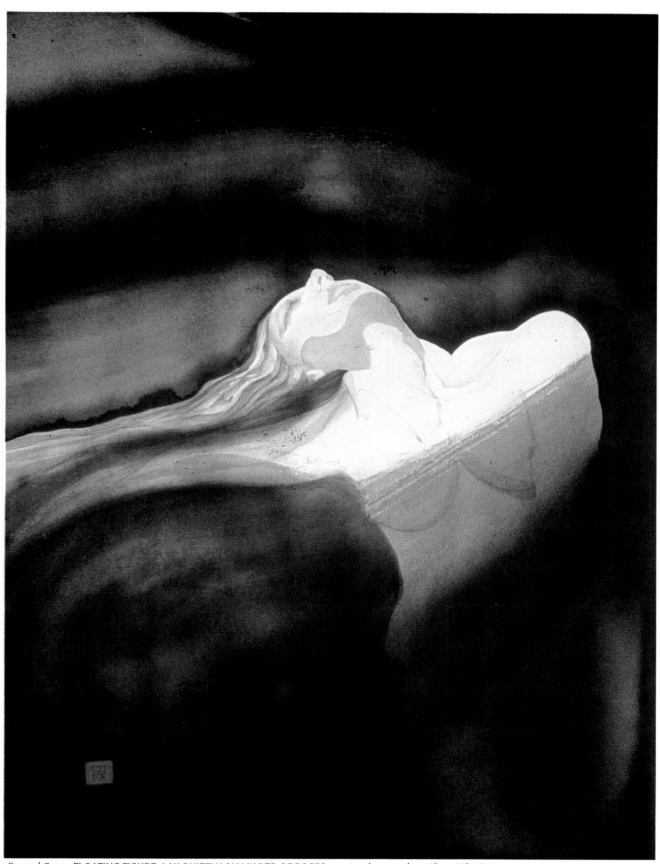

Samuel Corso, FLOATING FIGURE: LAY QUIETLY ON MY BED OF ROSES, sumi and watercolor, 40″ × 30″ (101.6 cm × 76.2 cm)

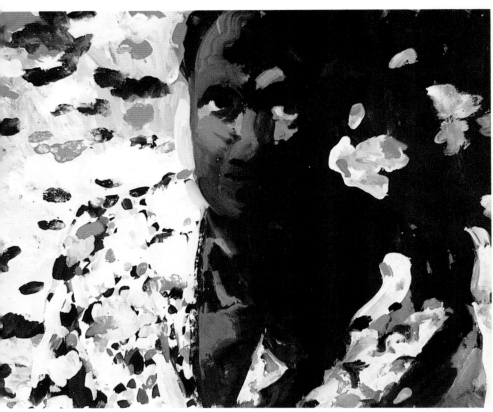

Jim Wilson, SELF-PORTRAIT, gouache, 13½" × 17" (34.3 cm × 43.2 cm)

Jim Wilson's self-portrait materializes smack in the center of complete blackness and rampant light; he seems to be either emerging into the white or slipping into the black. It's a powerful design, vigorously executed in sure flourishes of pure white and stinging color. The contrasts of chiaroscuro are definite. Jim's Hawaiian print shirt explodes into the space, scattering debris across the entire surface, but it does not diminish the astonishing black shape that discloses his smiling countenance and spews spots of darkness into the light side.

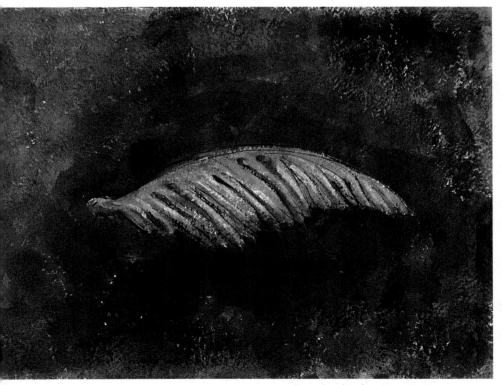

Michael Crespo, AN ANGEL'S WING ADRIFT, watercolor on handmade paper, 21" × 29" (53.3 cm × 73.7 cm)

This sheet of paper was made for me by a printmaker, Debi Bennett. I usually investigate the wing motif in oil paintings with heavy impasto textures. Debi's paper has a rich three-dimensional surface and is further textured with occasional shreds of silk. Its irregular absorption of paint allowed me to suggest that the chiaroscuro lighting is of a more celestial origin—the torn wing forever suspended in the dark void of space.

In this mixed-media painting, we find the activity of light gently revealed in a room constructed from dark, cool planes. There is a brief recognition of a grand piano, a favorite subject of Edward Pramuk. He began this painting with watercolor washes. As it progressed he switched to acrylic colors, which give him the option to go opaque with a much different surface effect than that of gouache. Acrylic washes have a slightly varnished look that contrasts subtly with the original watercolor.

A network of shapes lives in the darkness, perhaps lit by the moon or a glimmer from the stronger light entering at the right. The illumination divulges only enough to evoke a mystery.

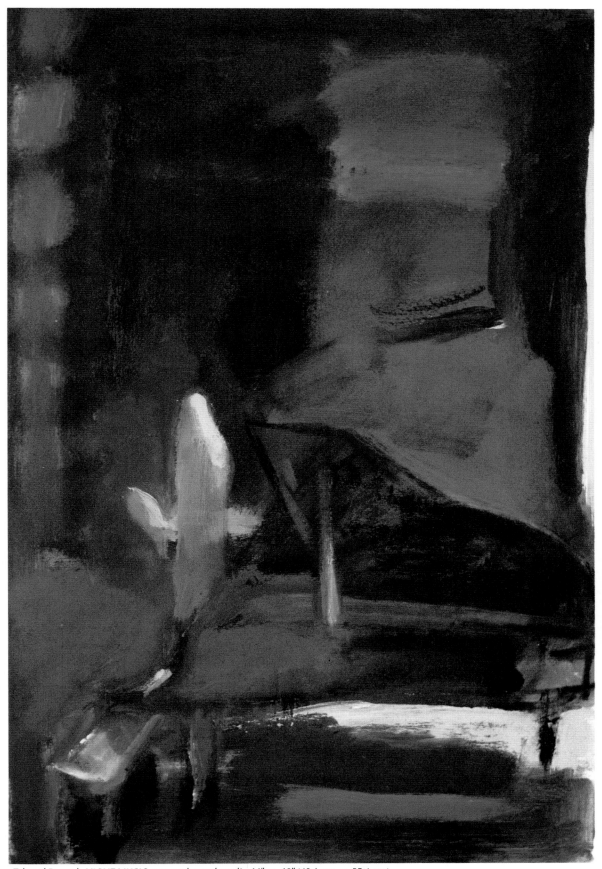

Edward Pramuk, NIGHT MUSIC, watercolor and acrylic, 16″ × 10″ (40.6 cm × 25.4 cm)

DAY 17
Give and Take

"In the old days pictures went forward toward completion by stages. Every day brought something new. A picture used to be a sum of additions. In my case a picture is a sum of destructions. I do a picture—then I destroy it. In the end though, nothing is lost. . . . But there is one very odd thing—to notice that basically a picture doesn't change, that the first 'vision' remains almost intact, in spite of appearances."

Pablo Picasso

The master's remarks impressed me deeply, providing an alternative that affected not only my painting process, but also my preliminary planning as to how to approach a particular painting. I consider two points of departure for each work. One approach is to contemplate and sketch my subject for a time and then attempt to paint it as quickly and efficiently as I can—*alla prima*, all at once. The other way, inspired by Picasso's statement, is to draw the subject directly on my watercolor paper as a very generalized sketch. Then I layer enormous amounts of painted information onto the paper, some of it describing the subject, most of it sheer indulgence in technique. At some point, when I feel that I have sufficiently overworked the painting and there is a generous amount of color and surface variation, I begin my search for the original subject, using a "lifting out" process, digging through the layers of paint, simplifying the complex, destroying much of what I have done, exploiting the residue.

No matter which procedure I choose, I give myself options. If I attempt spontaneity and fail, I revert to the second method. Conversely, if during my application of colors and marks I discover a painting before I begin lifting out, I stop and let it be.

Obviously I want you to embrace the second process, for it goes beyond overworking and lets you release all of your pent-up energies brushing, slinging, and splashing around loads of color. Of course, at some point you have to be responsible and find a painting in all of this.

Exercise: Subtractive Painting. Since you'll wind up doing a lot of scrubbing, it's important that you select a paper that will withstand some abuse. If you've been experimenting with papers all along, you'll probably have an idea of which to use. As I mentioned early on, the best I've found for such work is the Saunders Waterford Series 140 lb. cold pressed. If possible, use a full sheet for this painting, especially if you have not attempted a large painting yet. Your subject should be a single form. It may be an object or figure in space, or perhaps a landscape that you've reduced to a single mass of trees. Or you may draw on your inner resources for subject matter—a fantasy image or a geometric figure. A simple shape in a field will suffice. Once you have decided on something, sketch it out on your sheet of paper and start painting. Begin by loosely blocking in your subject and surrounding space. Vary your marks, color, and value. Paint some lines, build some texture. Once the image starts to develop, you might want to ignore it for a while and act on the paper as a whole. Paint a sequence of various washes, especially irregular ones. Pick up the corners of the paper and flow the paint in different directions. Put the painting on the floor and drip paint from on high. Squirt the surface with water. Try things you've never done before. Review all the ways of applying paint to paper and choose some that seem right. Let the paper dry completely between these applications. If it remains wet throughout, you may get mud. You want *layers* of all that you do. Also include some layers of traditional brushwork. Exploit rhythms and motions. Return to your subject occasionally, drawing it back up to the surface.

When you're exhausted, or you feel that the painting may be on the verge of self-destruction, it's time to reverse your process. But before you begin to lift out, choose one very opaque color such as cadmium red, yellow, or orange; Indian red; cerulean blue; yellow ochre; or any commercially prepared gouache color. Your choice should be one that you feel is

appropriate to your subject. It may well end up dominating the picture. Mix a thick puddle of the opaque color, paint it over the entire surface of your painting, and let it dry.

Now you are ready to paint by destruction. Have plenty of clean water, tissues, and paper towels on hand. You'll also need an appropriate scrubbing brush. I use one of those stiff nylon bristle brushes designated for acrylics. Begin by wetting the area of your primary shape with clean water. Scrub into the surface, constantly sponging up the layers with dry paper towels or tissues. Develop your subject in this manner until it begins to emerge in light. Your lifting out will bring out the light values. Vary the number of layers you lift out as you move around the painting developing form and space. You may want to add some detail as you work, swinging back and forth, adding and subtracting. You will discover some remarkably beautiful and seemingly impossible effects as you sort back through the layers of your recent efforts. As always, be conscious of what you're doing, and when it feels right, stop.

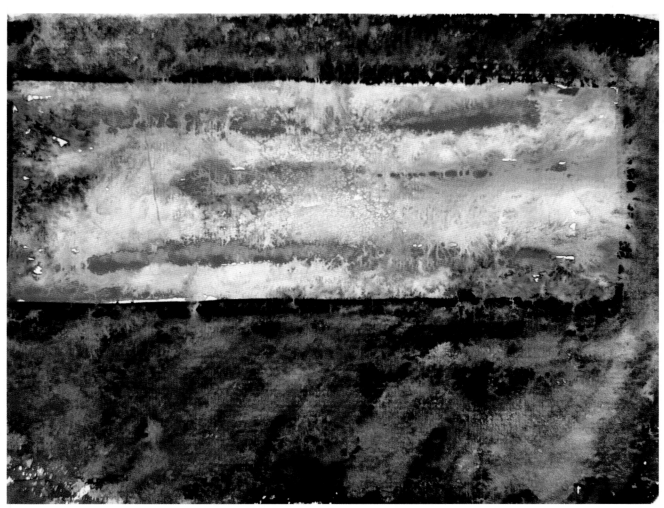

Shannon Cook, student work, 9″ × 12″ (22.9 cm × 30.5 cm)

Shannon Cook embellishes a wide rectangle with intense, splattered color in a field of warm gray. Both areas were the result of layers of wet-in-wet painting, the paper carefully soaked again after each layer dried. Her lifting-out process involved subtly modeling the rich texture into a more gentle presence. The push and pull of focus and blur inside the rectangle maintain the tension of trapped energy.

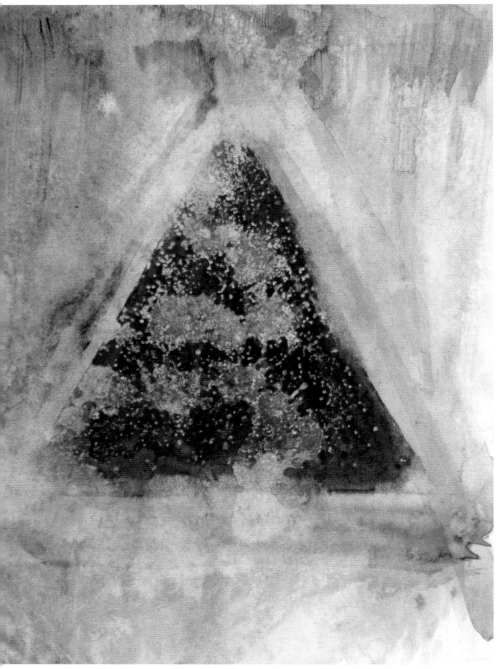

Mohd. Salim Hassan, student work, 12" × 17" (30.5 cm × 43.2 cm)

This fish (opposite), as a symbol of the soul, was not intended to swim in normal waters, and I wanted its image to be somewhere between a fish and a shimmer. The process I have described suited the ethereal nature of the subject. It would be impossible for me to remember every way that I abused this piece of paper. I began by splattering grays over the surface, concentrating on the fish shape. In the ensuing layers, I splashed on broad strokes, painted a variety of washes over the entire surface, and continuously reaffirmed the shape and surfaces of the fish with painted line. After hours of such play, I brushed a strong layer of Grumbacher red over the entire surface, including the fish.

Then came the process of searching back through the layers. I lifted the most out of the fish itself, but I also removed areas of the surrounding field of red. I softened the edges of the fish's form, being careful not to remove all of the linear development that occurred during the building-up process. My final act was to paint in the eye, obviously a crucial focus and significant to the narrative. The blue shape surrounding it was originally an unintentional splatter but was salvaged as a major color focus that contrasted with the hot red.

The mystery I sought was evoked, but only through the enigmatic results of this unorthodox process.

Salim Hassan built up fragile washes of grays over the entire surface (left), developing the triangle at the same time with outlines of primary color. Before he began his process of destruction, he dumped coarse salt into the wet paint of the dark triangle, producing a burst of white specks. The rest of the painting was reduced to very faint textures of the different lift-outs he used. There are traces of vertical scrubbing at the top, and the soft impressions of tissue are evident at the bottom. What is left of the primary colors complements the scaly triangle. Salim has evoked the curiously rich look of ancient frescoes decayed by the elements and the passage of time.

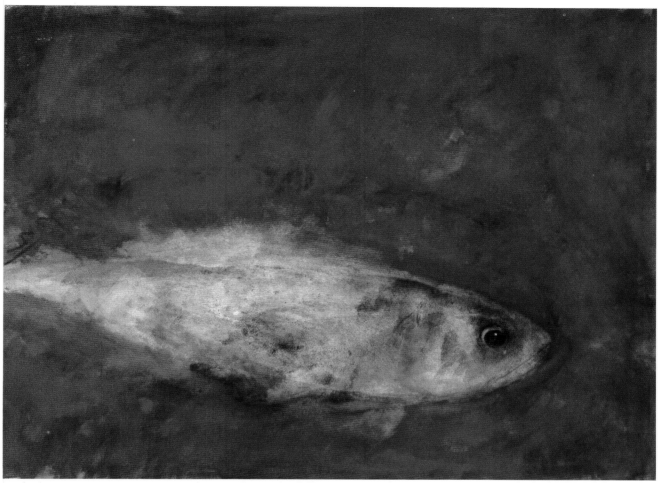

Michael Crespo, L'ANIMA, watercolor, 22" × 30" (55.9 cm × 76.2 cm)

In this painting, a commentary on un-necessary fish slaughter, I varied my approach to the technique. I built up the fish shape quite differently from the rest of the painting, using a variety of strokes, dips, and squiggles in a wide array of colors. The rest of the painting was covered with a series of orange and yellow horizontal washes; I kept my many passes as visible as I could. After covering everything with a thick coat of a dark green mixed from black and yellow, I began the scrubbing process, this time pulling out most of the final overlay, letting the remnants serve as a somber accent. The fish in this painting is notably less distinguished than the one in *L'Anima*. Here, it is decaying. But there is life in the eye and that suggests there is still hope.

Michael Crespo, DEAD FISH, watercolor, 22" × 30" (55.9 cm × 76.2 cm)

Joel West, student work, 22″ × 30″ (55.9 cm × 76.2 cm)

Joel West went through quite a few additions and subtractions before he was satisfied with this composition. Most of the foggy space in the lower portion is the result of monoprinting: He applied wet paint to a large piece of window glass and pressed his wet paper onto it, adding color to the glass and flipping the paper over until he had something he liked. The linear activity around his rectangle theme was also introduced onto wet paper. It seemed that for every application, he took something away. The swirling marks and more regular stripes were all part of the reduction process, as was the softening of planes at the bottom and the mutilation of the linear strokes. It's a lively event built on sporadic impulses of give and take.

Amy Karns, student work, 6″ × 8½″ (15.2 cm × 21.6 cm)

In this very determined little painting, Amy Karns reveals the simple sphere as her subject. She used a limited color scheme of red-violet and blue-violet to build her layers of texture and implied geometry, which were unearthed as she scrubbed back in. The dramatic white pedestal of light on which the ball rests was made by applying a masking solution at the onset and letting it stay until the very end. This enabled her to vigorously apply the subsequent layers without worrying about spoiling the paper white.

Regina Tuzzolino, student work, 20″ × 15″ (50.8 cm × 38.1 cm)

Johanna Glenny, student work, 15″ × 11″ (38.1 cm × 27.9 cm)

Regina Tuzzolino used a still life as the basis for this cacophony of shapes and textures. She built up information, tore it down, and built it back up again. Deep levels of space are revealed as soft, rubbed-out areas collide with harsh, nervous ones. The logically organized color reins in the swirling action: The circular blue and white focal point is bordered by red and green, with a shower of dominant yellow raining from above. Regina used no traditional implements to apply or remove the paint: It was poured on, thrown on, rubbed on with her fingers, scratched with sticks and spoons and any debris available. Although this volatile painting may be on the threshold of vaporization, it was conceived and orchestrated in an orderly fashion.

Johanna Glenny began this well-organized abstraction with a pencil drawing and some scoring of the paper. A series of washes and other spontaneous paint handling, including a very pronounced sponge lift on the left, followed. When the delicate pastel space was formed to her satisfaction, she slashed in the brilliant red-orange right triangle. Then she went to work digging in and softening most of the right side of the painting, as well as modeling the jagged edge and the interior of the monolithic subject. The result is a feast of inspired paint handling.

DAY 18
Grids

Picture plane is a term that is frequently bandied about and just as frequently ill-defined. Many try to make more of it than it is. It is simply the surface on which we paint. We are constantly grappling with its flatness, edges, and size. We confine images within its boundaries and make allusions to space extending beyond it. At times we sustain its flatness, and at other times we invent illusions to deny it. We glue things onto it, pushing it to three dimensions. We crowd it with a multitude of forms and images, or we adorn it with just one. We alter its edges from the traditional rectangle and make geometric and amorphous configurations. We refer to these machinations as denials or assertions of the picture plane.

Today we'll address yet another way of confronting the picture plane: the grid. A grid divides a picture plane into segments or units that may or may not be sequential or even related. Grid compositions insist that we view the whole at first glance but then force us to study the structure segment by segment.

Grid compositions are wonderfully variable, offering a vast arena for your more creative thinking and painting. A grid can contain *any* subject matter, from bananas to nonobjective splashes, repeated or altered from frame to frame. Its units may be geometric or amorphous or both. They may be all of one size or varied. The units may be ruled off and separated from one another with color or white paper, or they may abut, or both. Their boundaries may be deemphasized or only implied.

Exercise: Grid Painting. I would like you to paint a grid composition, the only instruction being that you divide the picture plane into segments. Your technique may be consistent or varied. You may do whatever suits you with regard to color and value.

Johanna Glenny, student work, 10" × 10" (25.4 cm × 25.4 cm)

Johanna Glenny tracks the contours of the face to organize this grid of narrative geometry. Keeping strong paper-white borders, she applied clean water to each shape and dropped in one or more colors, letting them dry as they may, producing a classic confrontation of hard edges and soft surfaces.

Clare Crespo, student work, 12" × 18" (30.5 cm × 45.7 cm)

My daughter Clare was excited about the prospect of a grid painting and produced this garish, smiling vision locked in the irregular geometric divisions. The bizarre figure was painted with watercolor pencil shadings brushed over with water. The surrounding shapes are straight watercolor. The continuous flow of the eyes and mouth through various shapes suggests the methods of stained glass, which is very definitely a grid structure. Clare has kept most of the values in the middle range, so when she darkens a few of the shapes in the background, some focuses are established that help disperse the central image.

Fifteen identical rectangles containing fifteen compositional variations on a slab of watermelon are the components of this fluid grid of observations by my wife, Libby. As we view the grid as a whole, the all-red center unit forms a hub for the surrounding activity. There is a linear sequential movement of red wrapping around the top left, while a more staccato lineup runs across the bottom. We sense how the green moves, and the blue, and the white. We follow the seeds around or let the different values guide us. We are also led to study the individual units, assessing them on their own as fifteen different paintings.

Libby Johnson Crespo, WATERMELON GRID, watercolor, 9″ × 10″ (22.9 cm × 25.4 cm)

Joel West presents a different experience in his grid, which is derived from the landscape. He has repeated the composition twelve times in slightly irregular formats. This repetition of an identifiable subject prompts us to view the work sequentially, looking from each part to the next, expecting something to change. Nothing really does, but there are some slight variations: The last frames at the right on all three rows are compressed, and the top two rows have yellow strokes that cross over into the frames below. The obvious event is the horizontal ornament on top of the mass of rectangles, which are all joined with paint in one way or another. It's a grid of fused repetition.

Joel West, student work, 22″ × 30″ (55.9 cm × 76.2 cm)

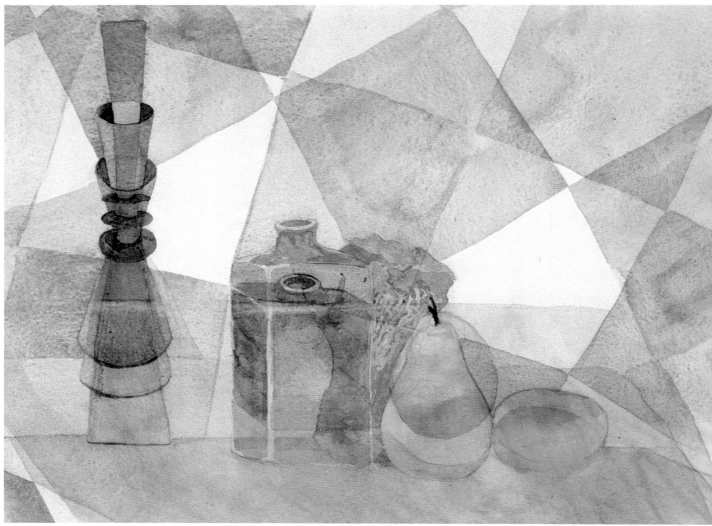

Joel Harrell, student work, 11" × 15" (27.9 cm × 38.1 cm)

Lewis Aqui uses a highly irregular grid format to intensify his surrealist juxtaposition of images (right). The flying grid components fracture and reconstruct a disjointed narrative of women, birds, water, land, and abstract elements. Time, as a sequence of events, is unintelligible here. Unity is found only in the color, in the wandering black, in the texture, and in the slats of the grid. The images expose themselves as they do in dreams. They provoke and disturb.

Lewis Aqui, student work, 10" × 15" (25.4 cm × 38.1 cm)

Joel Harrell painted a still life into a grid of repeating triangles (opposite). He used multiple viewpoints, letting the objects themselves contribute to the geometry of the grid. It's an effective, subtle merger of the perceived and the purely decorative. The still life exists, the grid exists, and, in a certain sense, both exist as one another. Joel's careful drawing and consistent, delicate handling of the paint convincingly float these transparent veils of reality and deception before our eyes.

Michelle Lowery used a collage technique to construct her grid (right). She gathered discarded watercolors and test strips, some her own and some collected from the classroom trash, and cut out many circles, all the same size, from these scraps. She experimented with different compositional arrangements before gluing the circles in place. The result is a grid of overlapping circles with irregular-shaped units but a regular arc that repeats throughout. Michelle has manipulated the incidental information into successful compositional patterns and spatial illusions, not to mention the actual low relief formed by the overlapping pieces of paper. The paper white is easily traced around the grid, as is the dark stripe motif of the top half. We follow green and blue around in various values and techniques, and the major warm focus of the center extends to the yellow circle at bottom right and the small pink and orange shape peeking out at top left.

Michelle Lowery, student work, 11" × 8" (27.9 cm × 20.3 cm)

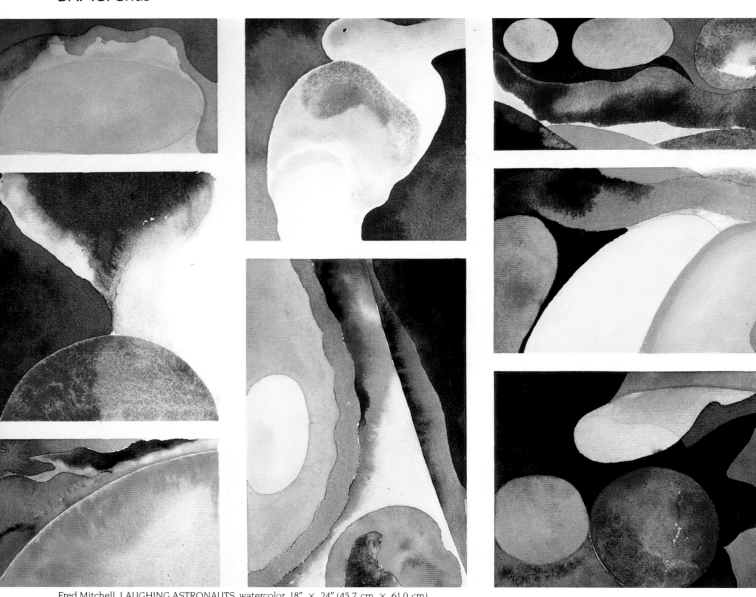

Fred Mitchell, LAUGHING ASTRONAUTS, watercolor, 18″ × 24″ (45.7 cm × 61.0 cm)

Fred Mitchell paints a grid of rectangles, each having different dimensions, and fills them with his imagined sightings as a space rider. The clean white divisions emphasize the rigid structure of the grid and enhance the diverse values and brilliant colors. Recurring oval shapes lead the eye from segment to segment, and Fred lets some of his shapes cross over boundaries. At the right, the shapes in the top rectangle spill into the composition below it. The orange shape in the middle rectangle in that column is completed in the bottom rectangle. Edges also correspond between the top center panel and the one below it. Fred makes these connections only from top to bottom, never horizontally. He also aligns the sides of the different components vertically but never allows their tops and bottoms to meet. These tactics clearly establish a vertical bias in the overall composition.

Fred Mitchell stages this grid composition in simple horizontal bands that are separated by distinct edges but united by overlapping washes. In dramatic contrast, two of the sections contain shape information, establishing focal points that break the monotony of the striped format. The primary focus is obviously the band containing the red ball of the setting sun, which bleeds into the yellow stripe above it and is flanked by two blue ovals. A secondary focus is the blue band farther down that depicts a less defined, more mysterious semicircular shape.

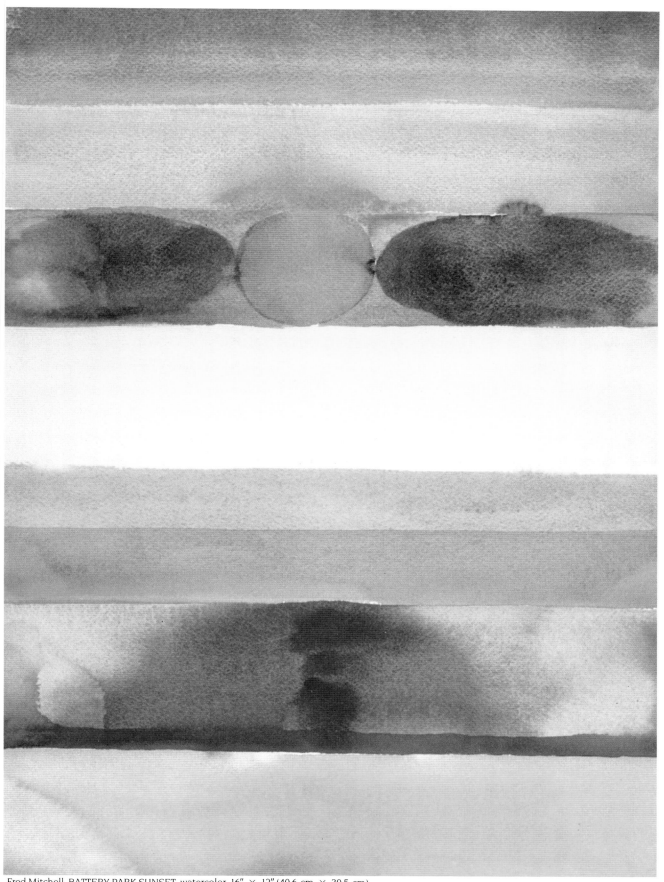

Fred Mitchell, BATTERY PARK SUNSET, watercolor, 16″ × 12″ (40.6 cm × 30.5 cm)

DAY 19
Remedies

I'm certain that you've accumulated quite a body of respectable paintings by now, some of which you actually feel quite good—maybe even ecstatic—about. But if you're like me and most other painters, you've also stowed away a cache of the ones that just didn't thrill you but were not bad enough to throw out. Perhaps you couldn't resolve them, or maybe you overworked them a bit, or you decided they might look better after a year of hiding in your portfolio (sometimes they do!). Today, pull them out and look them over. Although I can't promise a cure, there are some things you can and should try to revive them. Even if these last-ditch efforts fail, the pursuit can be enlightening and fun, and there isn't too much pressure to succeed. After all, you were probably going to toss the paintings out at some point anyway.

Lifting out. Soaking, scrubbing, and dabbing dry with a tissue can lighten a color to any degree you wish or prepare a form or area for repainting or alteration. Although some of the more potent stains may resist, you can remove enough to rework them. Lightly scrubbing with an ordinary eraser can lighten the value of a small area without wetting.

Transparent overpainting. Colors can be warmed, cooled, intensified, or grayed by simply painting transparent colors over them. Consider a transparent wash over the entire painting. I've salvaged many an ailing painting this way.

Opaque overpainting. You can make a number of changes by overpainting with the more opaque colors or with transparents to which Chinese white has been added. If you don't want the lighter values the Chinese white produces, use designer's gouache or casein. The flat, opaque areas will contrast with the transparencies, adding another dimension to the painting. Sometimes a white highlight or two will snap a painting together. Chinese white used full strength will accomplish this.

Cutting shapes from the surface. Extremely hard-edged paper-white shapes can be reclaimed in a painted area by cutting partially through the paper with an X-Acto knife or a razor blade and peeling off the surface layer. You can leave the new shapes white or apply another color; just remember that the texture will be slightly different from that of the rest of the painting.

Adding line. Drawing into a painting with pen and ink can transform it dramatically, enhancing contours and producing new textures. Lines of ink or opaque colors can also be applied with a brush.

Modifying edges. Consider changing or altering some or all of the edges of forms by overpainting or by lifting out and repainting.

Collage. More radical, but sometimes most effective, is gluing on prepainted shapes of paper or unpainted shapes that can be left white or painted after application. You're not only masking undesirable areas but also producing surface variation.

Cropping. If you can't resolve a painting, look for smaller compositions within it. Search around, using sheets of white paper to make new outer edges. Sometimes just a quarter of an inch taken from one edge can satisfactorily reposition everything.

If the painting is still failing, take it outdoors and hose it down. The water pressure will remove most of the color without disturbing the surface. You can then begin again, using the faint traces of line and color as underpainting.

Exercise: Rescuing a Painting. For today's assignment, find an old painting you consider a failure and seriously attempt its resuscitation. In fact, why not spend the entire day reviving all your old dogs? Approach these pursuits with the optimism you'd have at the start of any painting. This is another assignment, not a desperate act.

Christy Brandenburg, student work, 9" × 12" (22.9 cm × 30.5 cm)

This self-portrait humorously "peeking over the fence" was once a full-face composition. Christy Brandenburg was not pleased with the handling of the mouth, so she bravely sliced out that portion. There is no doubt that she found a superior, if unorthodox, composition; it is bolstered by some exceptional brush gyrations and invigorating color. There are big risks in cropping a face. Usually the form flattens out, but in Christy's painting the planes of the face are so well sculpted that they hold up well under the knife.

Michelle Lowery originally painted a still life of her small potted garden of cacti. At some point the painting died from overworking, a situation we've all experienced a few too many times. She detected an interesting light on the cacti and tried to lift out the background, but all she got was a muddled mess, so she abandoned the painting. Later, with my encouragement, she carefully cut the three cacti away from their surroundings and experimented with the cutout on some new backgrounds she had painted. She settled on this warm, skylike wash and glued the cacti down, transforming them into major desert vegetation. Because the cacti were originally painted on heavy 300 lb. paper, the three-dimensional effect of a shadow box is evident. The little arcing highlight on the cactus on the right was made by cutting away a thin layer of the paper with a knife. She added a little color to tone down the white.

Michelle Lowery, student work, 7½" × 7" (19.0 cm × 17.8 cm)

Michael Crespo, UFFI, watercolor, 6½" × 12" (16.5 cm × 30.5 cm)

This painting of my charming little parakeet hung around in my portfolio as a nondescript pencil and light wash drawing for years. It was not very impressive, but I kept it because of its subject. One day I decided to take the risk and try to make a painting out of it. Voila! With a little glazing, Uffi was parading through a smoky yellow space in full-color plumage.

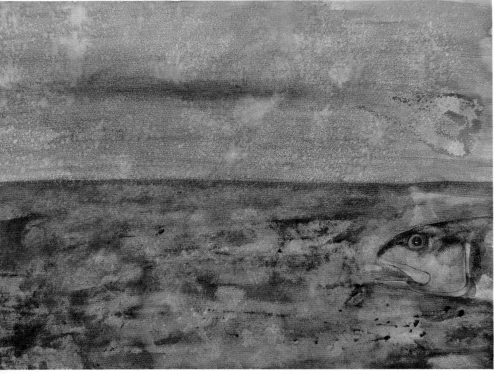

Michael Crespo, LANDSCAPE, watercolor, 22" × 30" (55.9 cm × 76.2 cm)

This painting underwent major revision as I transformed it from a simple fish swimming in water to a more surrealistic image that commented on environmental pollution. The original painting was not only unresolved visually but, more importantly, had not a hint of any personal statement. After some thought, I introduced the horizon line and painted the terrain that immediately set the fish in flight. I "polluted" the environment by laying down irregular washes, the last of which I sprayed with my mister to form the dense texture of water stains in the sky.

Scot Guidry's zany portrait of his cat exhibits the most farfetched compositional solution yet. He drew the cat with watercolor pencils, then gently wet the marks to form the light washes that describe its gentle volumes. I would have been satisfied with the very astute portrait, complete with cleverly detached tail, but Scot wasn't. He later convinced his friend and subject to dip his pads in some dilute colors and collaborate in the effort. The cat resolved the painting by "walking in" the decorative paw motif in the background.

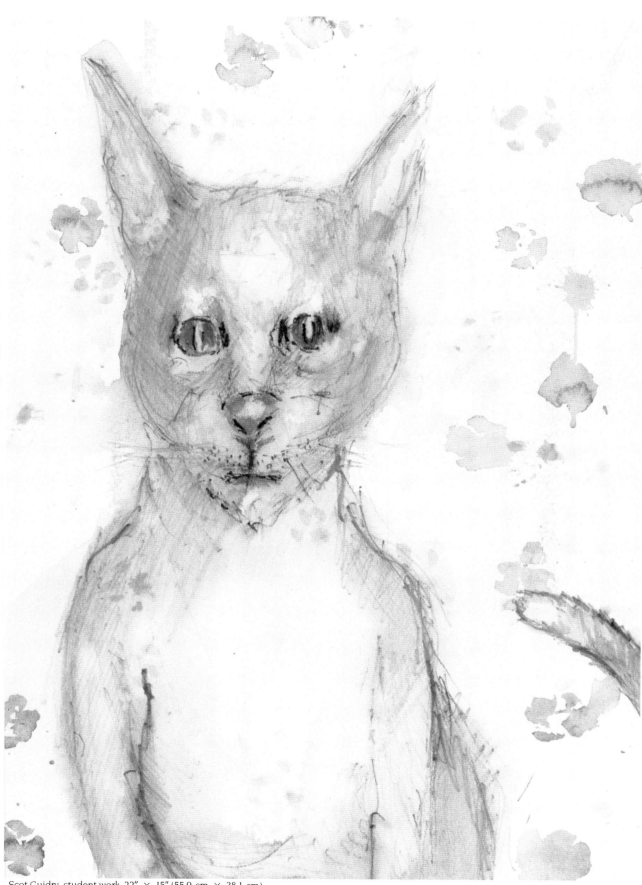

Scot Guidry, student work, 22″ × 15″ (55.9 cm × 38.1 cm)

I made the first version of this painting while sitting in a park in Florence one afternoon. I was well pleased when I finished it, but when I looked at it a few weeks later, I was less satisfied. At the time, the dark gray background was very developed, with columns and dark arched doorways. I decided that this was distracting the eye from the foreground plane, where the pigeons who were my main subject matter were. I gently scrubbed the area down with a brush and clean water, not really lifting out but melting the forms together into a subtler focus. There are a few remnants of the original. I emphasized the foreground further by scumbling some Chinese white to form the speckled highlights. My instincts proved correct; the painting took on new vigor.

Michael Crespo, PIGEONS IN A PARK, watercolor, 7½″ × 12″ (19.0 cm × 30.5 cm)

I transformed the entire nature of this painting of four asparagus stalks on a purple drape. It was once a very careful, conservative rendering that was deadly boring. At first I didn't want to admit defeat because of the time I spent on the rendering. But obsession eventually got the better of me, and I set out to make it a painting I could live with. First, I scrubbed the entire drape down to the grainy texture of the paper. Then I scrubbed some of the detail out of the stalks and deleted the rest with thick, sloshing strokes of phthalo greens and cadmium yellows. I found excitement in bold animation and followed through with the strong blue shadows and some occasional flurries of my no. 3 script brush. The more blatant contrasts of light and color fell on my eyes much more comfortably.

Michael Crespo, ASPARAGUS, watercolor, 11″ × 15″ (27.9 cm × 38.1 cm)

Louise McGehee, student work, 9″ × 12″ (22.9 cm × 30.5 cm)

Louise McGehee was dissatisfied with this brimming bird's-eye view of a fishing lodge when she returned to her studio from a vacation. There was no major flaw, but somehow the infusion of light throughout the painting diminished the focus of the red structure in the complementary green surroundings. Likewise, the foreground tree, in sharp focus at the bottom of the painting in the first version, was also drawing attention away from the camp, which she was determined to nudge into the role of primary subject. So she made two minor alterations that accomplished the task. First she scrubbed out the base of the offending tree, then she outlined the camp and immediate surroundings with pen and ink. Wisely, she made a few perfunctory lines elsewhere in the painting so the remedy would not appear too deliberate. As Louise demonstrated, sometimes drastic measures are not needed to reclaim a seemingly lost work.

DAY 20
Painting in Series

The transition from student to independent artist is not an easy one, as I learned when I completed my formal education. I was brimming with ideas and anxious to get on with the work of painting, but the busywork of buying supplies and preparing my studio seemed to consume a lot of my time. In fact, I probably had the cleanest, best-stocked, best-organized studio of my career—but there were no paintings. Just plenty of procrastination.

The problem was that there was no longer somebody coming in daily with a project for me to work on. I would have been happy to work once again with even the most boring of my teachers, just to be told one more time what to do and how to do it. But I knew it was time for me to take that responsibility myself, to become my own motivator and guide.

Then I remembered some advice a teacher had given me years before. He said that If I ever had absolutely nothing to paint, I should slap down a couple of objects and paint a still life. So I did. And that painting became a series of still lifes that steered me ahead into the language of paint and form, ahead into the ongoing search for *my* marks and *my* voice. This series of still-life paintings was the first of many, and I learned that the life of an artist is primarily occupied with sustaining subjects and ideas through periods of time and scores of paintings, moving to the next series only when the present one is exhausted.

You've painted these past nineteen problems (thirty-nine, if you worked through my first book) very much as a student. Now I assign you one last problem that involves slipping into the transition zone and taking on the responsibilities of an artist. Decide on a subject and begin an ongoing series of paintings. Remember, if you can't think of a subject, just start with a little still life. I'm not even going to require a set number for you to make. Let each painting direct you in some way into the next. Define your own problems and expressions as you work.

In hopes of providing a little insight, I've extracted some paintings that are parts of ongoing series by students, seasoned professionals, and me.

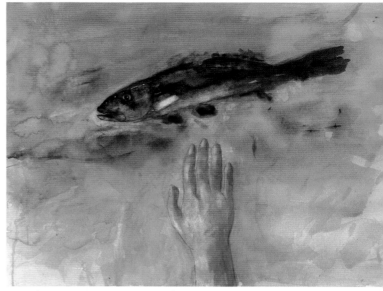

Michael Crespo, SEARCHING, watercolor, 22" × 30" (55.9 cm × 76.2 cm)

I have used fish as subject matter throughout my career; my treatment of them has ranged from strict observation to symbolic fantasy, as you can see from my paintings illustrated in this book. These particular three paintings initiated a yet-unfinished subseries in which a hand and a fish interact in various ways. I invited the question of whether the hand had entered the fish's domain or vice versa—or perhaps they are both out of their element and the rendezvous is occurring in more spiritual surroundings. In this painting, the hand is drawn from and meant to be my own. Aside from that, the title discloses about as much meaning as I care to divulge.

I began with a drawing of fish and hand. Then I applied a number of irregular washes, immediately lifting out the interiors of the two subjects with tissue. The fish and hand were developed separately. The blue of the fish is the significant focus, contrasting with the warm space. I brought the hand into the dialogue by washing Indian yellow over it to bring it luminescence. In fact, it literally lights the belly of the fish; this effect was an afterthought and I achieved it by considerable scrubbing and lifting out.

A strongly delineated child's hand enters from the left, releasing a more indefinite fish, in another of my series of hands and fish. I wanted the environment of this painting to appear as if the viewer were underwater, seeing without the aid of a snorkling mask. I accomplished this by first painting the fish and the small area of debris at the bottom onto wet paper. After some drying time I wet the paper again and applied a yellow wash, dropping in the blue-gray that appears as the unfocused forms at the right, and the sienna that surrounds the hand. The hand was drawn in last, over the sprawling puddle. I drew it with dark color and a tiny brush. A little bit of lifting out gave it a gentle volume, but my intention was for it to remain a harsh, linear form to contrast with the murky, soft-edged depths.

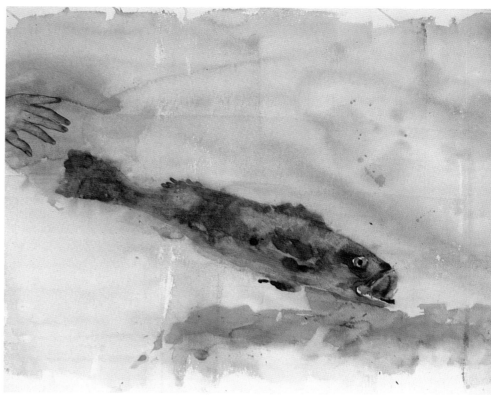

Michael Crespo, EVERY LAST TOUCH, watercolor, 22" × 30" (55.9 cm × 76.2 cm)

In this third variation on a theme, I drew a boundary separating a hot, brightly illuminated world from a cool, smoky abyss. The fish metamorphoses as his heavy, dark volume moves into the light and immediately becomes linear, like the beckoning hand. I was strongly influenced by the drawing in Indian miniatures while this painting was in progress. I painted the washes on either side of the border separately, allowing them to mingle but careful not to let the indigo move too far into the yellow. I stood over them as they were drying, manipulating the flow of color by constantly adjusting the tilt of the board to which the painting was attached. Finally the waves settled into place, disclosing a painting that is far richer in symbolism than I had intended.

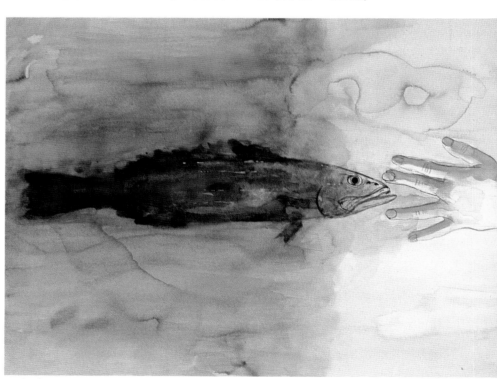

Michael Crespo, INTO THE LIGHT, watercolor, 22" × 30" (55.9 cm × 76.2 cm)

133

DAY 20: Painting in Series

Madeline Terrell chose the ducks that inhabit her yard as subjects for part of a lengthy series of barnyard animal paintings. This elegant bird poses in a space that consists of three distinct zones held together with a broad, operative value range. The foreground is graced not only with the duck's presence but also with intense contrasts of color temperature and value contained in short, jabbing strokes. Paper-whites confront dark shadows as the cool tones of the duck set the yellow-green grass ablaze. In the middle ground, just behind the center tree, values and colors are closer relatives, blurred together in a horizontal band of wetter technique. In the background are larger, more simplified shapes than in the foreground, but the value contrast is repeated.

Madeline Terrell, student work, 9½" × 13½" (24.1 cm × 34.3 cm)

Madeline uses the hard, dark shapes as stepping-stones through the space of this two-duck painting. She's shoved the creatures into the middle of the space; their strutting white forms are juxtaposed with bright yellows to form the predominant focus in this painting of many focuses. Our eyes move into the space not only on the horizontal shadow planes but also along the strategically placed vertical trees that take us back beyond the hedge. There, color, value, and focus dramatically change, signaling the deep space of aerial perspective.

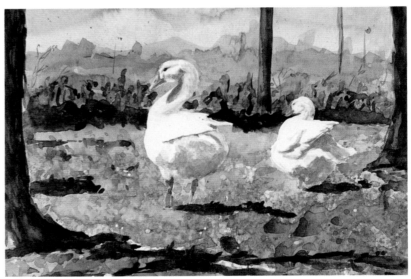
Madeline Terrell, student work, 9" × 13" (22.9 cm × 33.0 cm)

Madeline almost fills the space of this painting with the two preening ducks. She uses a subtle mixture of blue, gray, and violet to paint their backlit forms. A cool, dark foreground plane is topped with two almost black shadows that suddenly give way to a shrieking bright middle ground. The background darkens just behind the webbing of the fence, sandwiching the streak of light. The shapes are bolder and simpler in this painting. All three zones of space are alarmingly distinct, but they are bridged and interlocked by the mammoth Pekins.

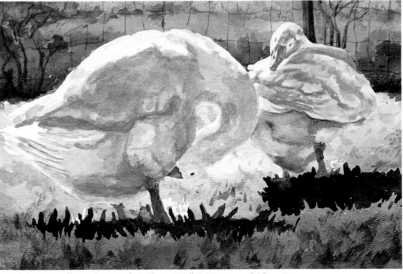
Madeline Terrell, student work, 9½" × 13½" (24.1 cm × 34.3 cm)

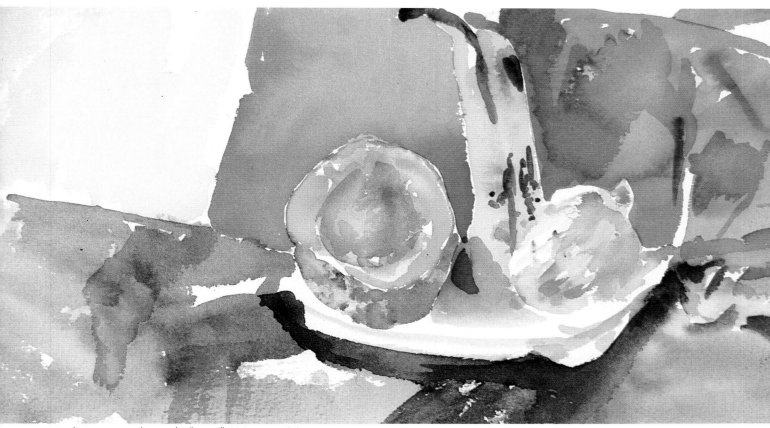

Leslie Wagner, student work, 9″ × 16″ (22.9 cm × 40.6 cm)

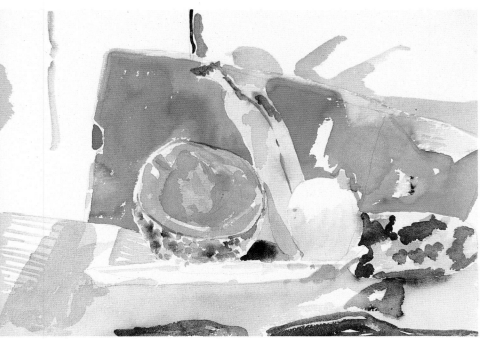

Leslie Wagner, student work, 11″ × 16″ (27.9 cm × 40.6 cm)

Here are two paintings out of a series Leslie Wagner made from a simple still life with a cantaloupe, a banana, and an onion as principals. Leslie uses exuberant sweeps of her brush to describe the objects. Notice how casually her brush scampers around this painting, depositing the yellow of the wall into the gray at bottom left and the orange of the cantaloupe into the dull red at top right. The banana reigns, sporting its dark accents and standing straight in the horizontal surroundings.

Leslie moves to the right and zooms in closer on her subject in this second painting in the series. The racing diagonal ground plane rights itself somewhat, with some textural hints on the left indicating that it is covered with newspaper. The white of the paper rules; the color is distributed simply but dramatically. The pink plays backdrop for the fiery yellow-orange of the melon, and a deeper cadmium yellow smear on the pale banana appears again as the brazen half-circle clinging to the left edge, keeping our eyes moving.

135

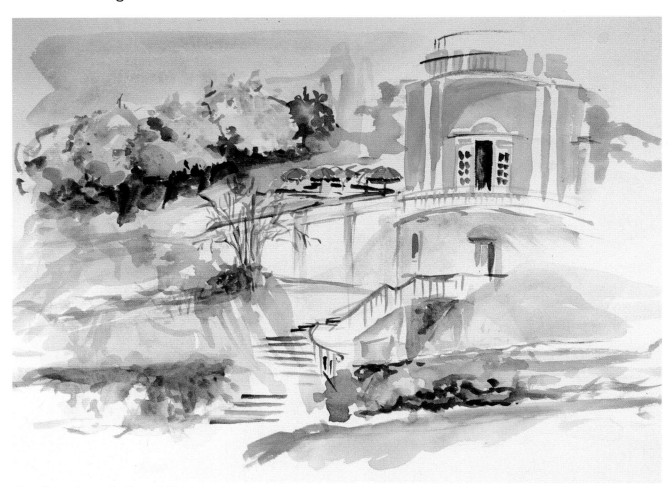

Ellen Ellis, student work, 11″ × 15″ (27.9 cm × 38.1 cm)

Ellen Ellis made this refreshment bar in the Boboli gardens in Florence the subject of a summer-long series. She applies sketchy but descriptive strokes as she charts the course of the afternoon sun through the many levels of the airy space. The brightly colored nook of umbrellas traps the eye only for a moment; then it moves along to other areas of interest on the facile surface.

Ellen has moved close to the building in this version; the gaggle of umbrellas now barely peeks over the distant ornate wall. She maintains her keen attention to light, but it is obvious from the slight cooling of the color that this represents a different time of day. Her proximity has resulted in greater emphasis on the details of the building that is so powerfully presented in vignette form. Its deep linear perspective does not vanish in a gray distance but abruptly culminates in an explosion of garden foliage.

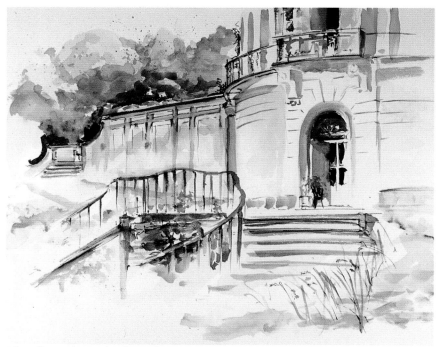

Ellen Ellis, student work, 11″ × 15″ (27.9 cm × 38.1 cm)

136

Scot Guidry, student work, 8½″ × 12″ (21.6 cm × 30.5 cm)

Scot Guidry selected folks on a neighborhood street as the theme of his series. In this selection, he jots down with friendly precision the portraits of three subjects that float in a pale fog surrounding the dissociated features of a fourth. It's a composition that would occur casually in a sketchbook, but its symmetry leads me to believe he carefully plotted the curious grouping.

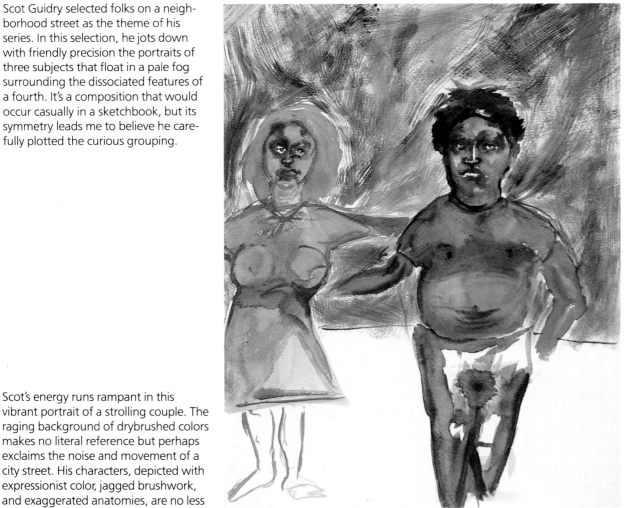

Scot's energy runs rampant in this vibrant portrait of a strolling couple. The raging background of drybrushed colors makes no literal reference but perhaps exclaims the noise and movement of a city street. His characters, depicted with expressionist color, jagged brushwork, and exaggerated anatomies, are no less rambunctious.

Scot Guidry, student work, 20″ × 14½″ (50.8 cm × 36.8 cm)

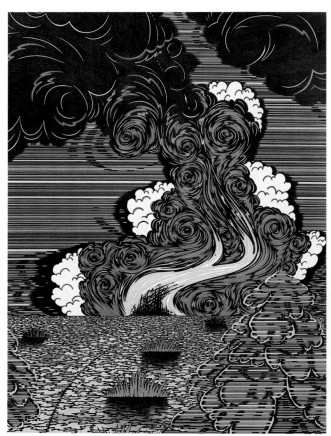

Walter Rutkowski, BONFIRES ON THE LEVEE, watercolor and graphite, 40″ × 30″ (101.6 cm × 76.2 cm)

On Christmas Eve in this area of Louisiana, huge bonfires of burning rubber tires light the night for miles along the levee of the Mississippi River. Walter Rutkowski has chosen this festive ritual as the subject of this series, which, unlike the other examples, is complete in four paintings. He even intends that they be exhibited together in sequence.

Walter insists on the hardest of edges dominating his work. These edges join with menacing shapes, jolting color, and strongly contrasting values to conjure an eerie vision of this south Louisiana rite. There are areas here and there where he employs a fuzzy, contrasting edge: in the dark shadows surrounding the white smoke, for example, and in the shadows of the clumps of weeds in the foreground. But these are the only relief from the razor-sharp contours that rule the painting. He achieves such astounding clarity by laying in transparent watercolor shapes and bordering them with a graphite pencil. Surprisingly, all of the black shapes that suggest ink or black paint are drawn with graphite pressed hard into the surface of the paper. The force of his manipulation of media and formal elements blisters the eye in this intense vision.

Walter Rutkowski, BONFIRES ON THE LEVEE, watercolor and graphite, 40″ × 30″ (101.6 cm × 76.2 cm)

This second painting in the series presents a fire that rises more vertically, as if the wind died momentarily. The placement of objects in the foreground has changed slightly, and the black has become more dominant, with the "eyes" of the whirling flames much more evident.

Walter Rutkowski, BONFIRES ON THE LEVEE, watercolor and graphite, 40" × 30" (101.6 cm × 76.2 cm)

The yellow shape of flame is now gesturing on the other side of center from the very first painting. The foreground tree form has returned to the right corner, but the arcing line retains its right-to-left direction, and once again we are at a greater distance from the fire. In this series, Walter has moved us systematically through space and time, assembling the parts into a logical experience. But I'm still not certain if there is one fire viewed four times from four viewpoints, four different fires, or some other combination. I'm more satisfied thinking there are four separate fires; I seem to move along the river at a faster clip that way.

Walter Rutkowski, BONFIRES ON THE LEVEE, watercolor and graphite, 40" × 30" (101.6 cm × 76.2 cm)

The point of view seems to have shifted to the other side of the foreground tree form, which was on the right in the first two paintings. The bonfire is closer, now manifesting another slightly variant structure. It is even more vertical than in the last painting, and the components of the swirls are more complex. Notice that the line that begins at bottom right and traces the curved contour of the foreground runs in the opposite direction. It's almost as if we are circling around these fires in this sequence of paintings as the river snakes along its course.

The bright lights and colors flow as fruits from a cornucopia in this painting from Jim Wilson's series on night life. The black line flows with steady energy, promoting itself as well as identifying the inhabitants of this bristling scene. The imposing large palm fronds on the left join with the vertical walls of the right and rear to frame and stabilize the tangled mass of musicians and customers. Jim's hand is remarkably confident and expressive, and this composition exemplifies the reaches of freedom to be attained within the artist's self-imposed structures.

Jim Wilson, BAR SCENE IN CHALMETTE I, gouache, 13½" × 17" (34.3 cm × 43.2 cm)

Again the plant and walls envelop the space, but in this version of the same scene, the focus is shifted to a more narrative element. The white light on the man in the foreground moves us back past an eerie visage making eye contact with us to a singer belting a song into a red microphone. There is also a wonderful dialogue between the casual linear construction of the foreground space and the dense color shapes of the background. I also sense an implied "x" movement across the painting from corner to corner, intersecting at the standing man's gray head at dead center. The isolation of hot reds in the icy field is a powerful compositional ploy.

Jim Wilson, BAR SCENE IN CHALMETTE II, gouache, 10" × 14' (25.4 cm × 35.6 cm)

Jim Wilson, THE OASIS, gouache, 11" × 15" (27.9 cm × 38.1 cm)

A maze of dancing color fragments captures the pulse of life in this third bar scene. We are led by the ellipses to a potent vision of a woman juggling a snake; she and her audience are lit from below as if they circle some ritual campfire. Despite this compelling narrative, we are led further into the space, across the crowd and deep into the room where a blistering red rumbles in its confinement. This bar series is a result of Jim's annual treks to the New Orleans jazz festival; the paintings illustrate how lovingly he embraces the region's flamboyance.

DAY 20: Painting in Series

Dee I. Wolff has created a mysterious, deep, dark, smoky, red-violet universe in which to float the central flower form and its flock of worshipers. All her images are visual metaphors of places and events. She says she doesn't always understand the images as she paints, but later on they become clear. This is not to say that she is out of control; on the contrary, a great deal of our knowledge and emotion is rooted deep within us, and we must always be willing to allow this wealth to surface in our images.

Dee I. Wolff, RESONATION SERIES, gouache on Pondicherry paper, 7″ × 10″ (17.8 cm × 25.4 cm)

A scintillating narrative takes place over another rich and spacious underpainting. The little figures take flight into a fanciful tree, while charmed leaves fall and spiked forms of sparking yellow light enter at the right. Dee develops these paintings from a black base over which she paints most of the billowing semitransparent field. The gouache becomes more opaque as she identifies her characters. If you look through the hard green smacks of leaves, you can glimpse the layers of wet pentimenti swirling below. Although this tree appears to be alive and thriving, it is not rooted in the earth but is free in flight.

Dee I. Wolff, RESONATION SERIES, gouache on Pondicherry paper, 7″ × 10″ (17.8 cm × 25.4 cm)

There is a celebration in the ordered design of this third painting that speaks to me in the same language as Giotto's fresco of the Last Judgment in the Arena Chapel in Padua, Italy, another work that expresses the great harmonic disposition of the universe. Here, legions of the little beings, now a bit more abstracted than in the previous paintings, cluster around a wreath of nature that in turn circles a single energy, the giver of light.

Dee I. Wolff, THE FARM, gouache on Pondicherry paper, 7″ × 10″ (17.8 cm × 25.4 cm)

Index

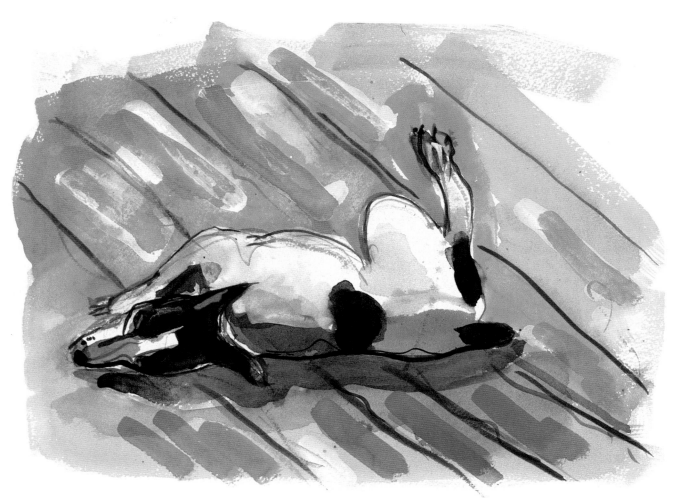

Michael Crespo, QUEENIE ROLLING ON THE PORCH, watercolor, 11″ × 15″ (27.9 cm × 38.1 cm)